inspired boloring FLOWERS

This edition published by Parragon Books Ltd in 2015 and distributed by

Parragon Inc. 440 Park Avenue South, 13th Floor New York, NY 10016 www.parragon.com

Copyright © Parragon Books Ltd 2015

All images courtesy of Shutterstock

Introduction by Dominic Utton Designed by Karli Skelton Production by Emily King

All rights reserved. No part of this publication may be reproduced, stored in a retrieval system, or transmitted, in any form or by any means, electronic, mechanical, photocopying, recording, or otherwise, without the prior permission of the copyright holder.

ISBN 978-1-4748-1740-0

Printed in China

inspired boloring

FLOWERS

COLORING TO RELAX AND FREE YOUR MIND

Bath • New York • Cologne • Melbourne • Delhi Hong Kong • Shenzhen • Singapore • Amsterdam

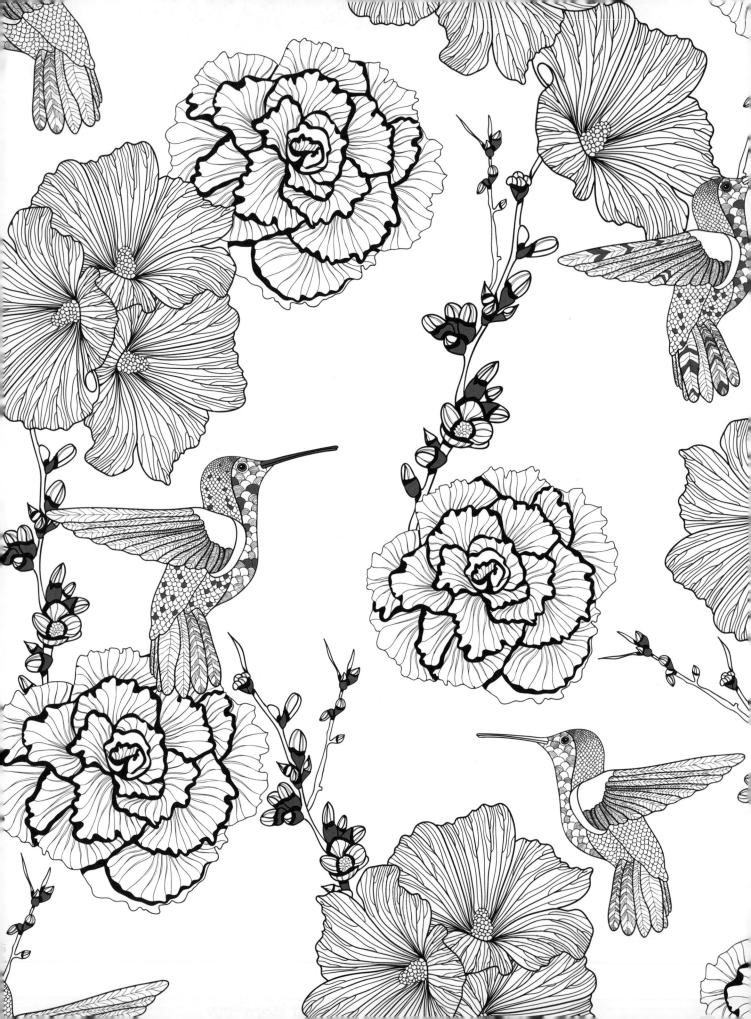

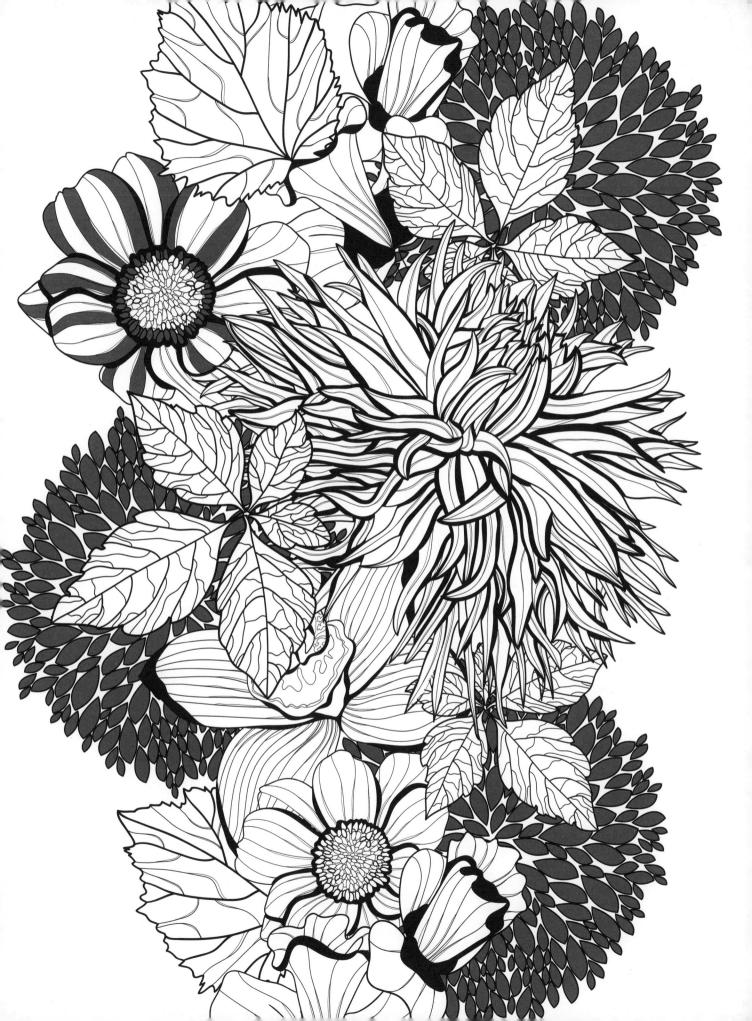

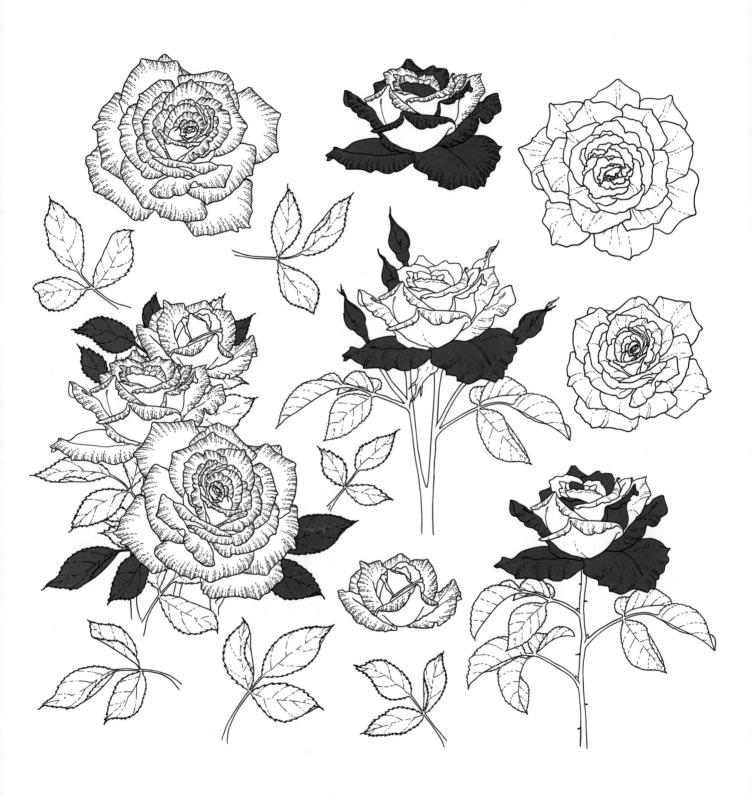

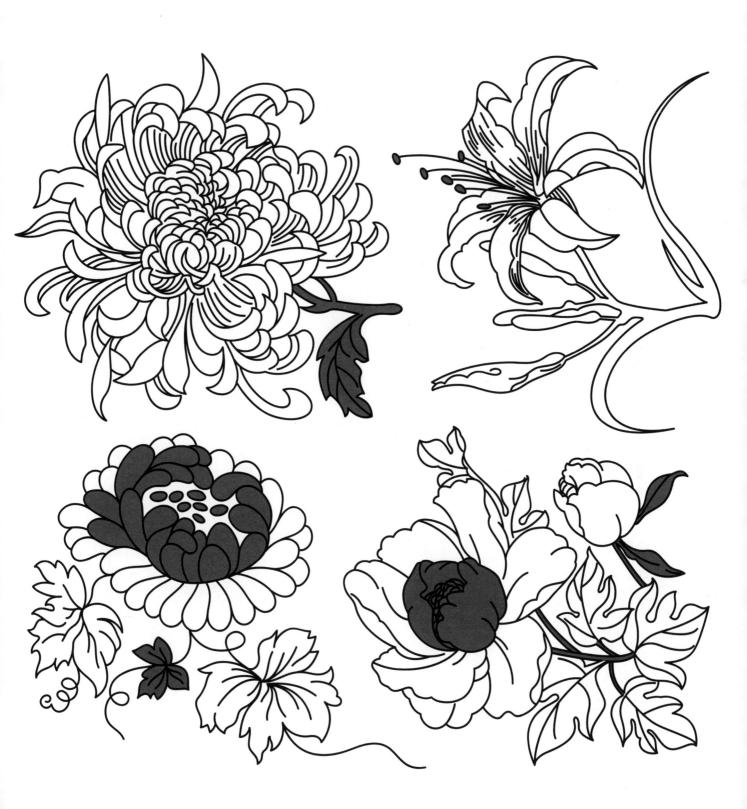

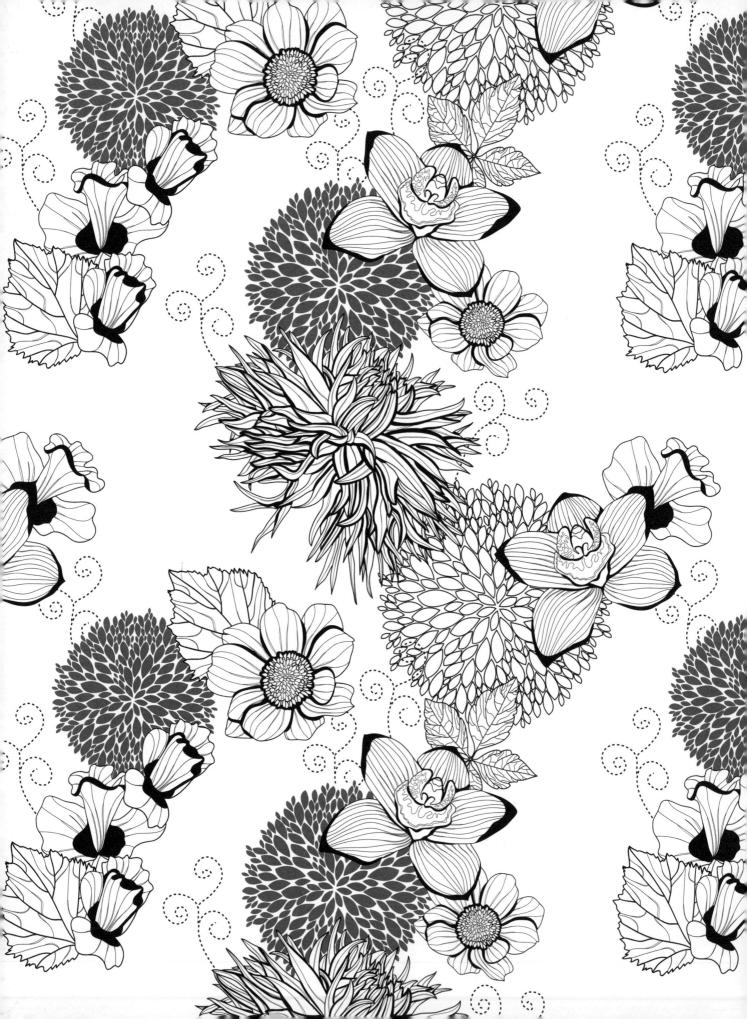

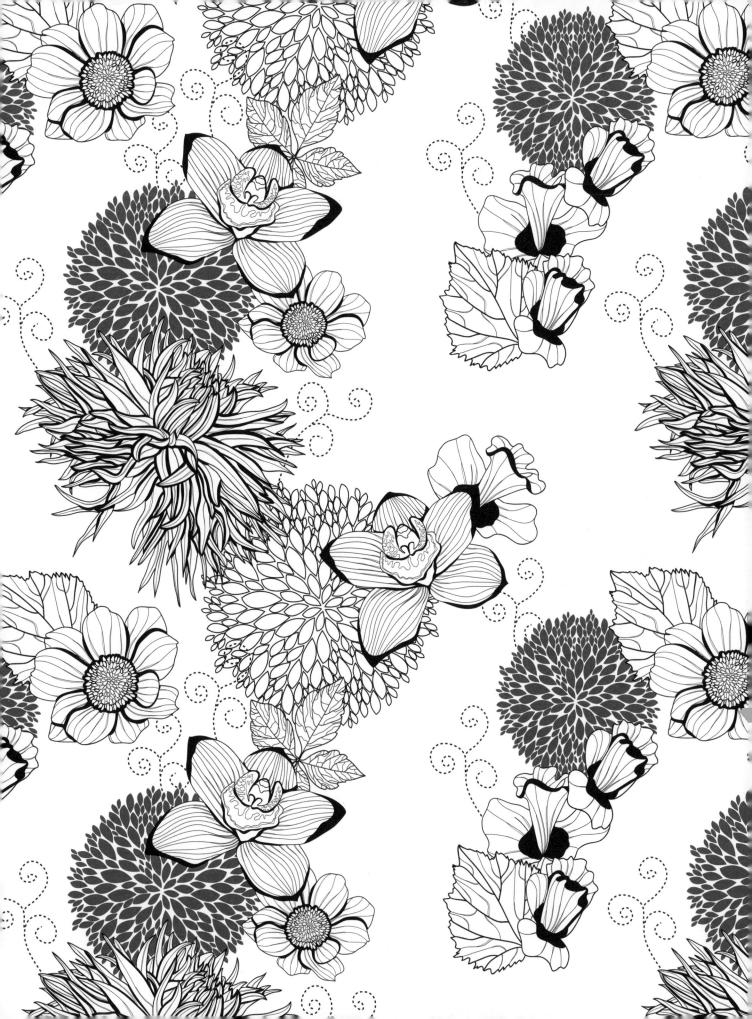

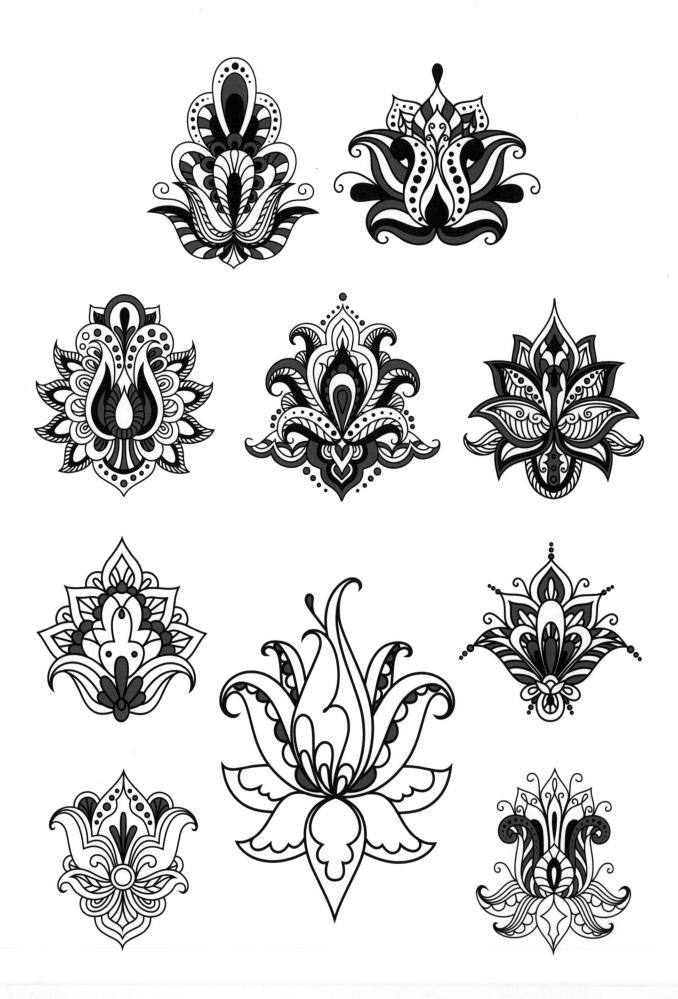

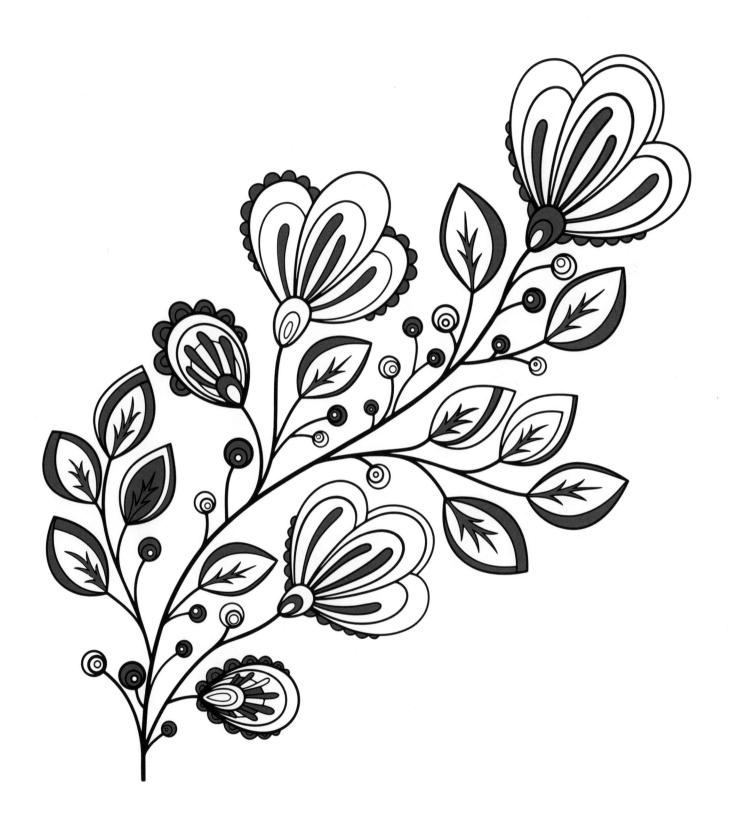

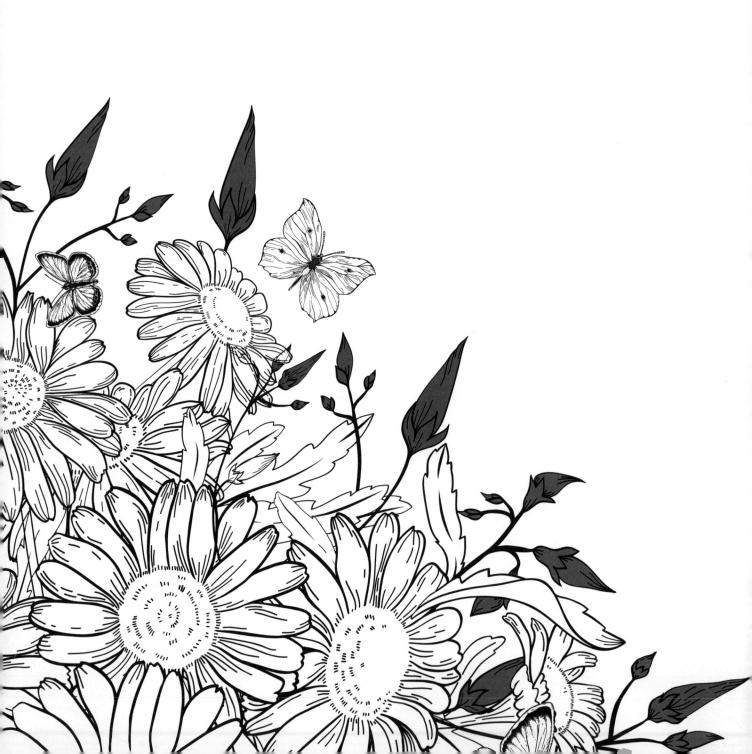

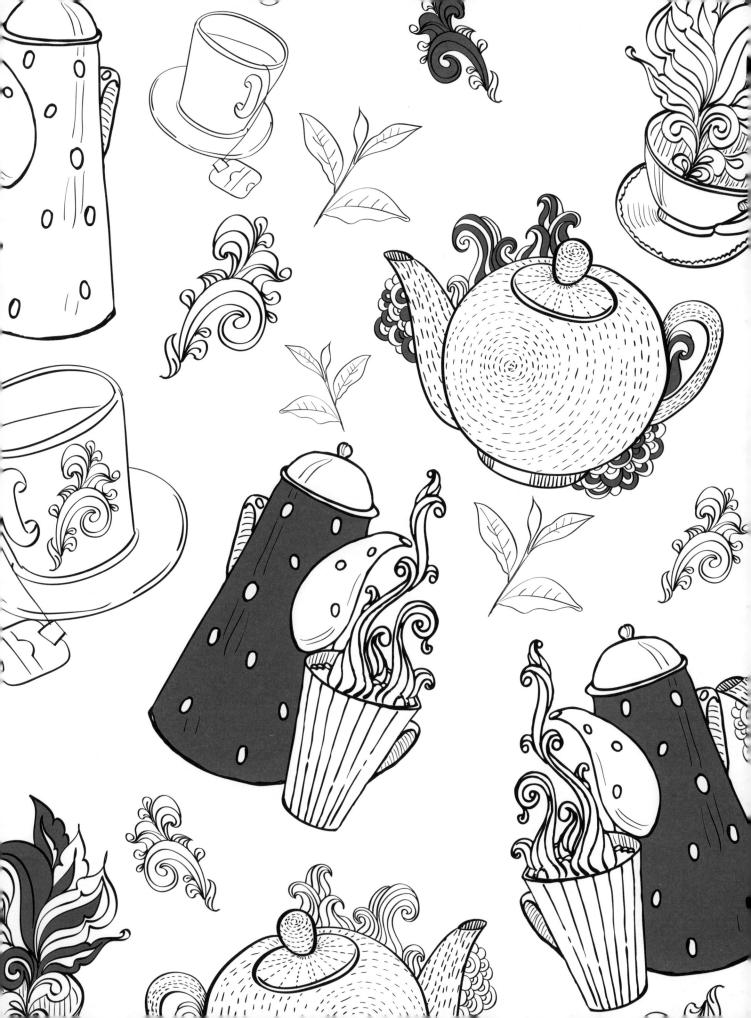

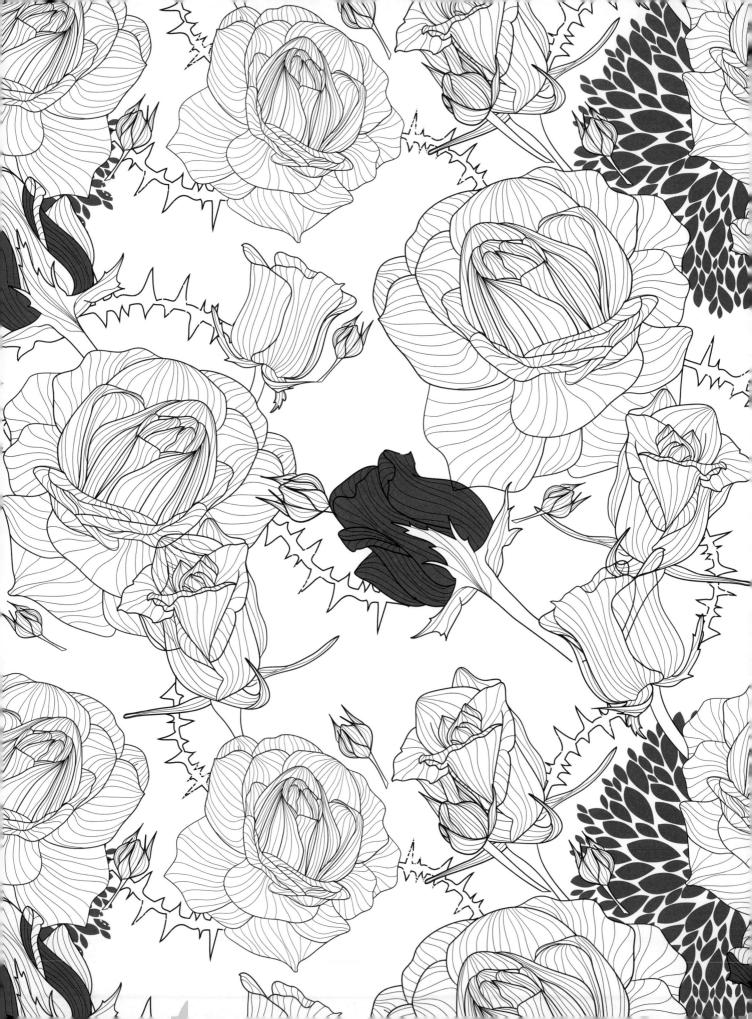

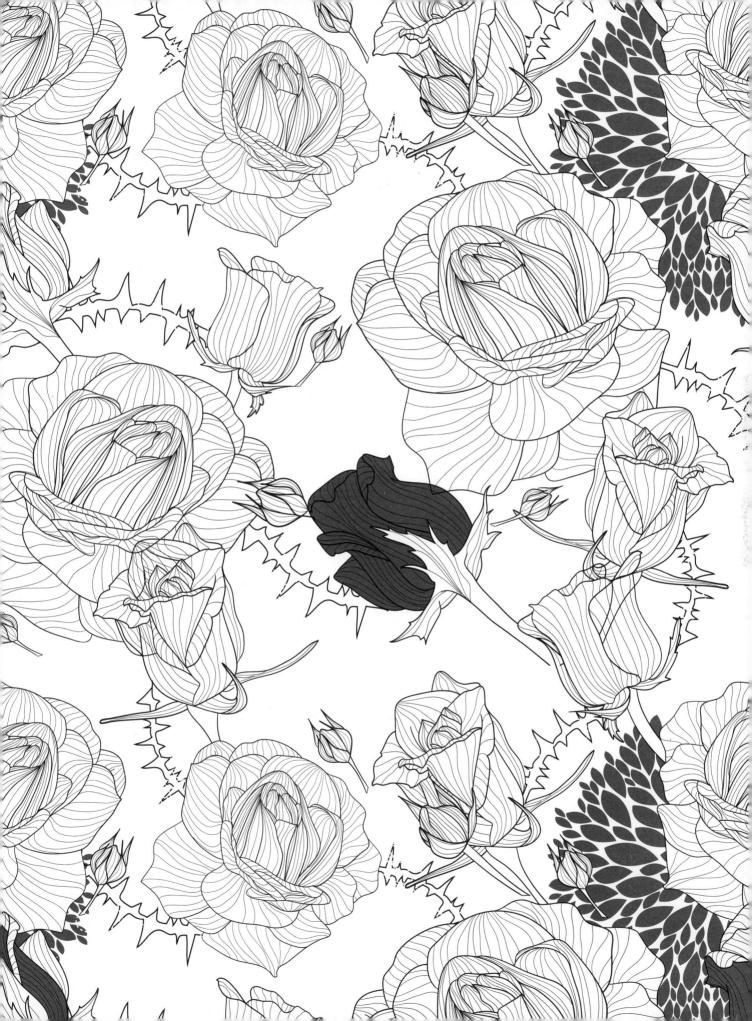

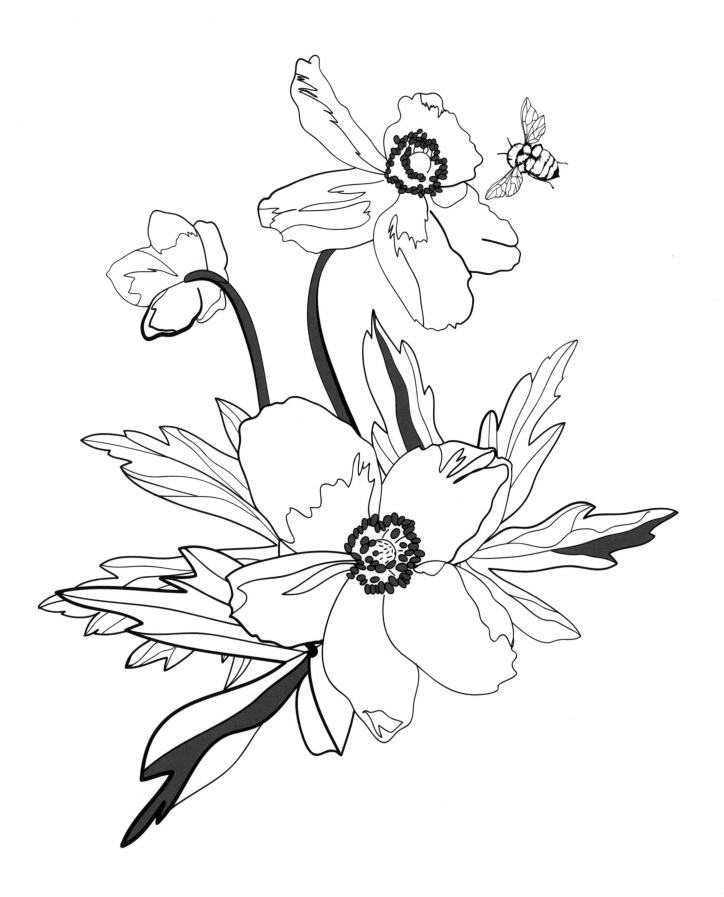

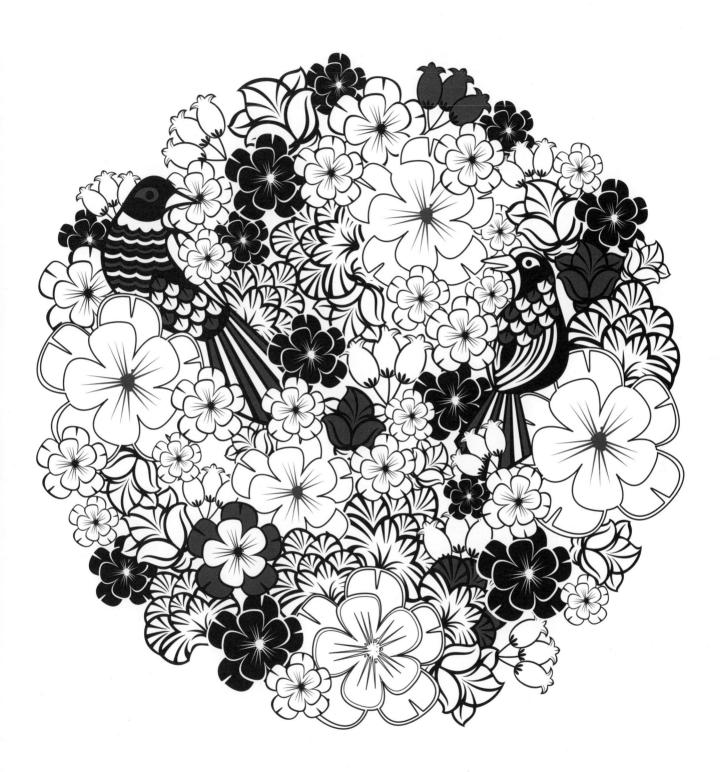

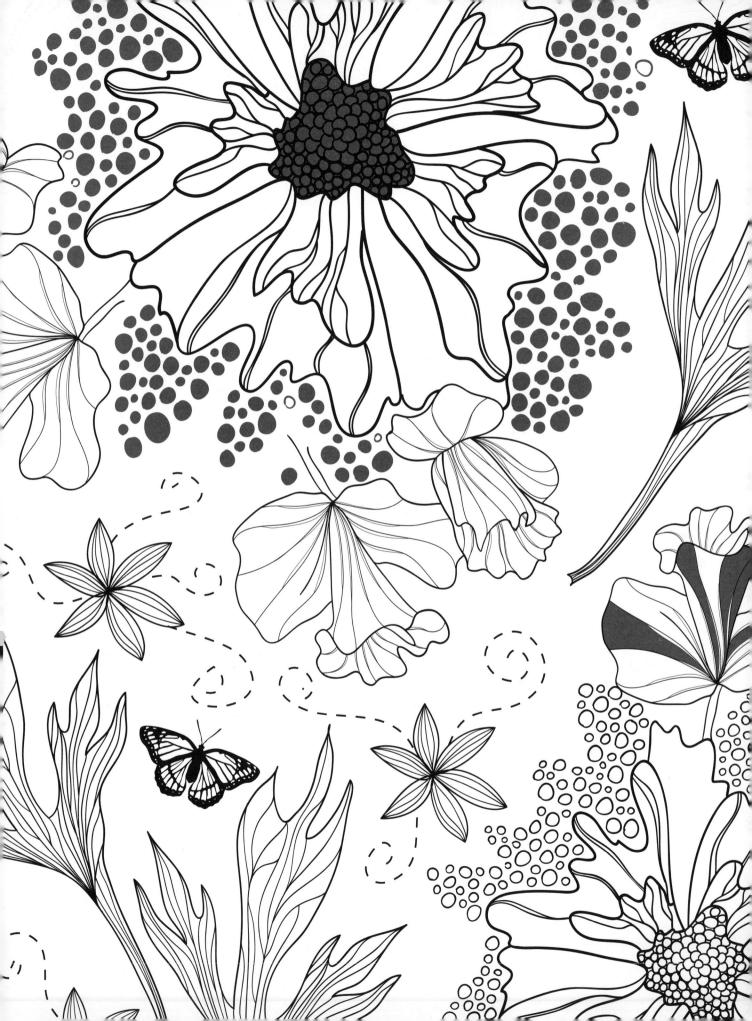

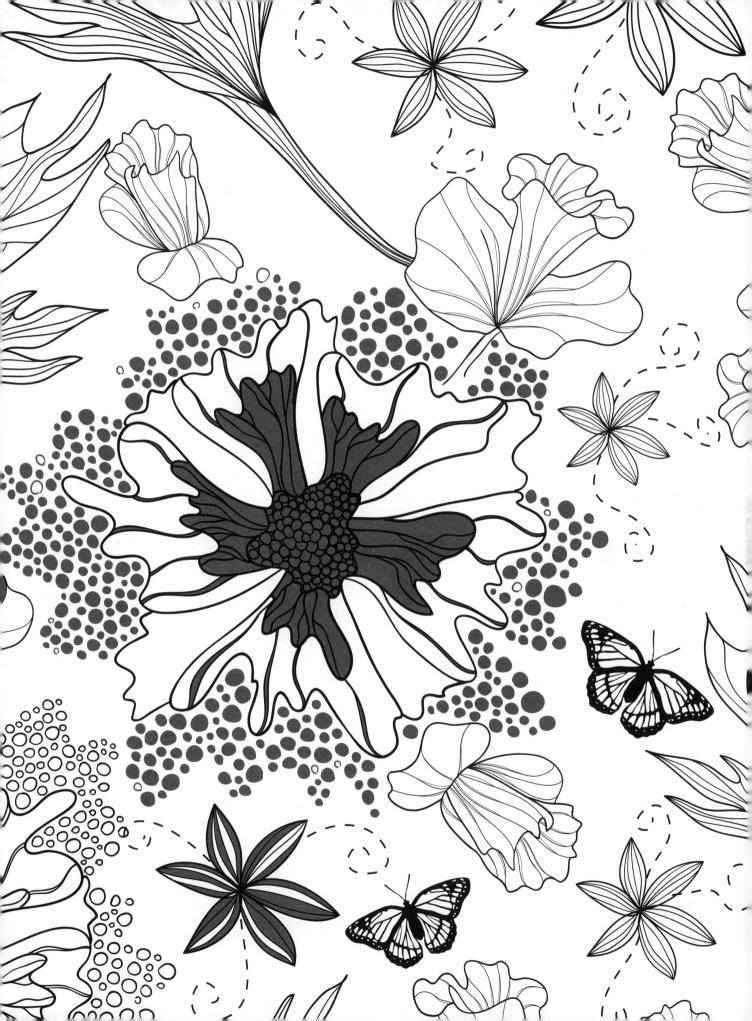

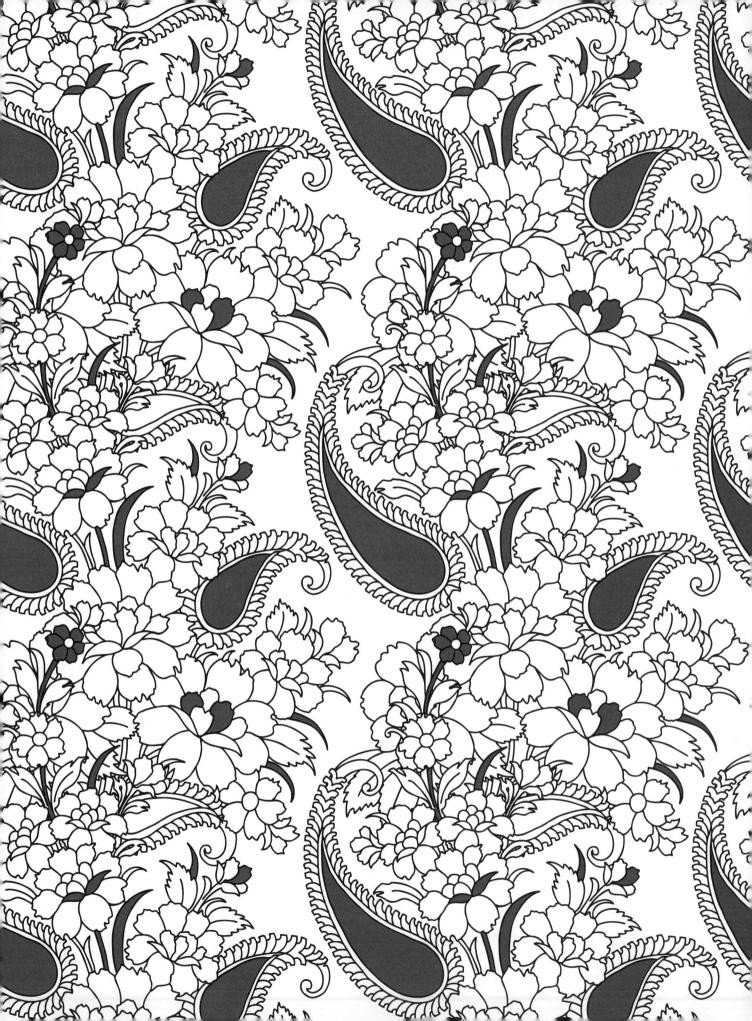

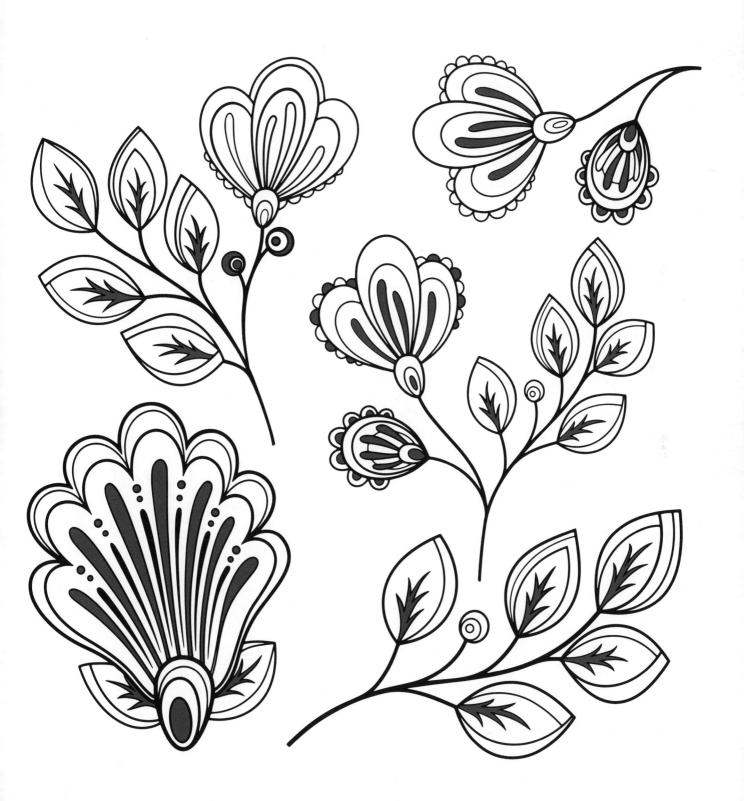

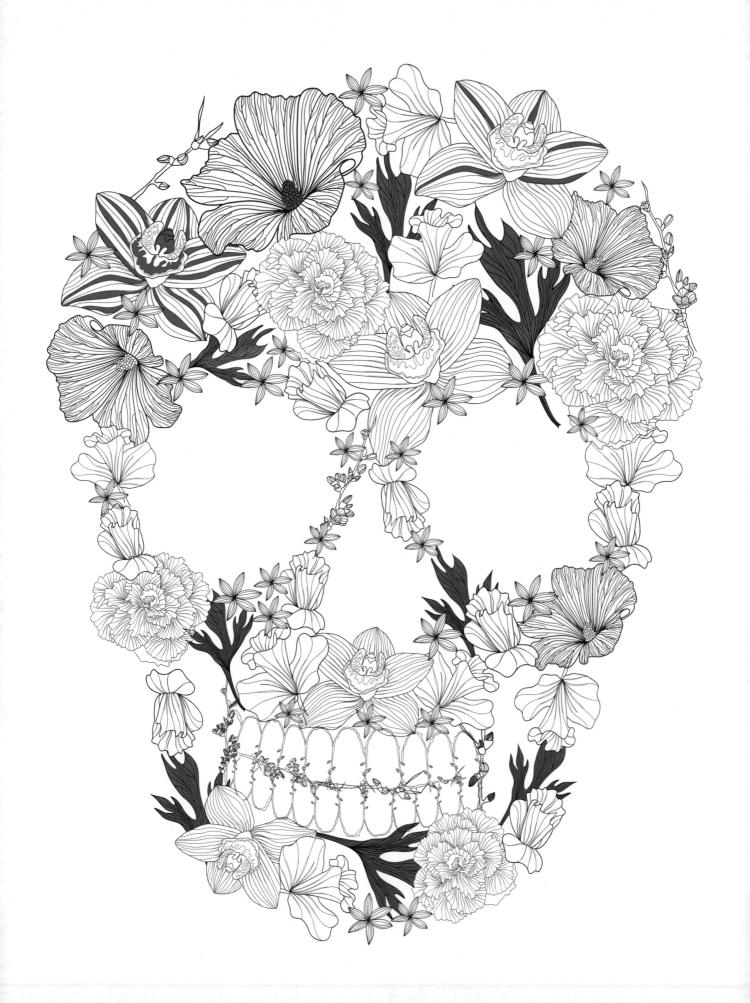

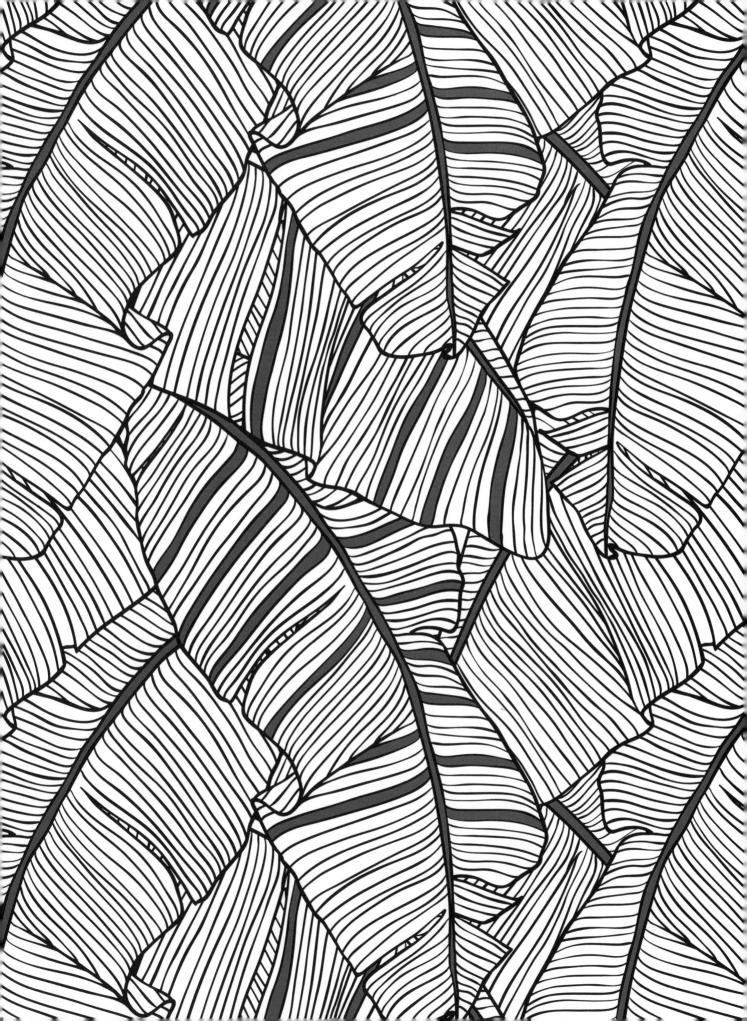

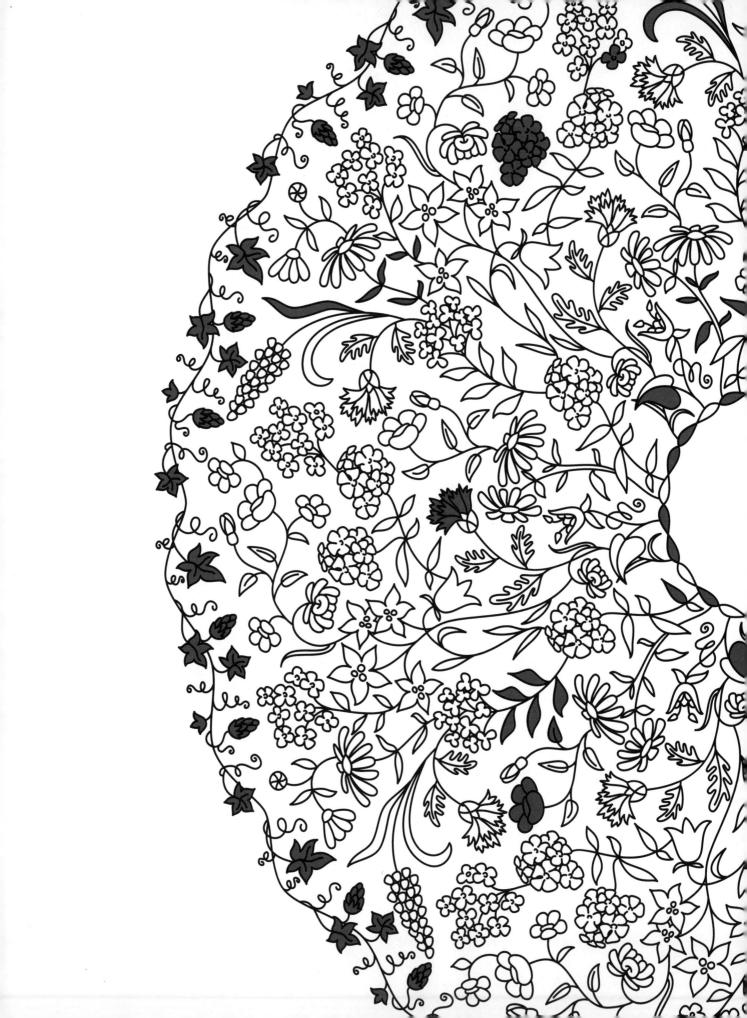

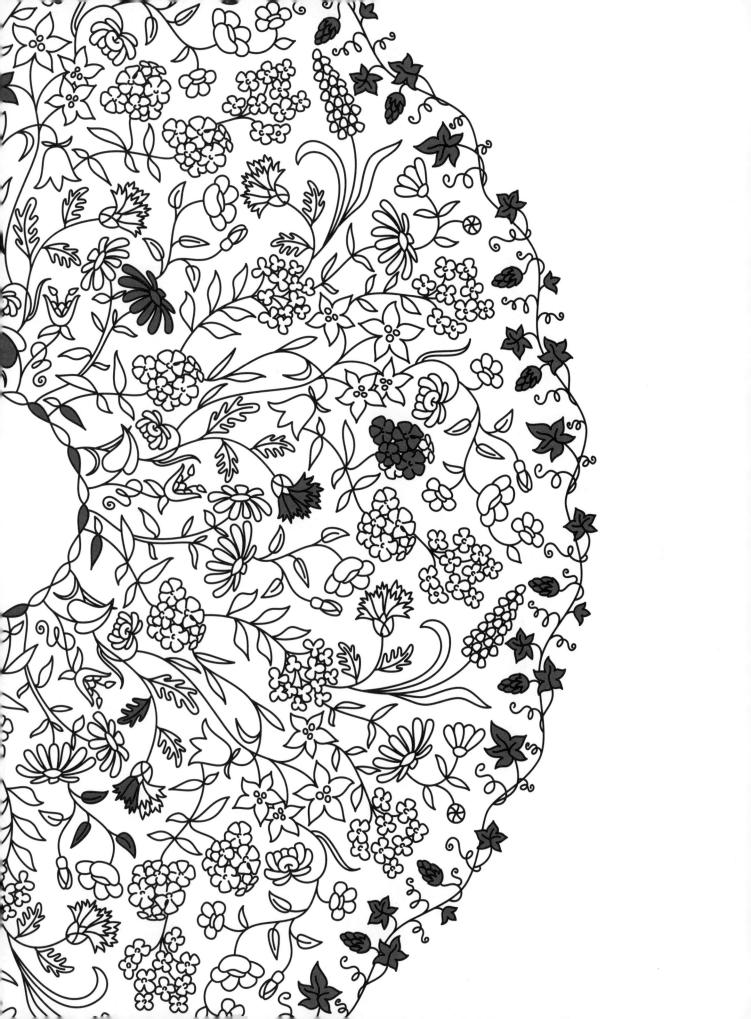

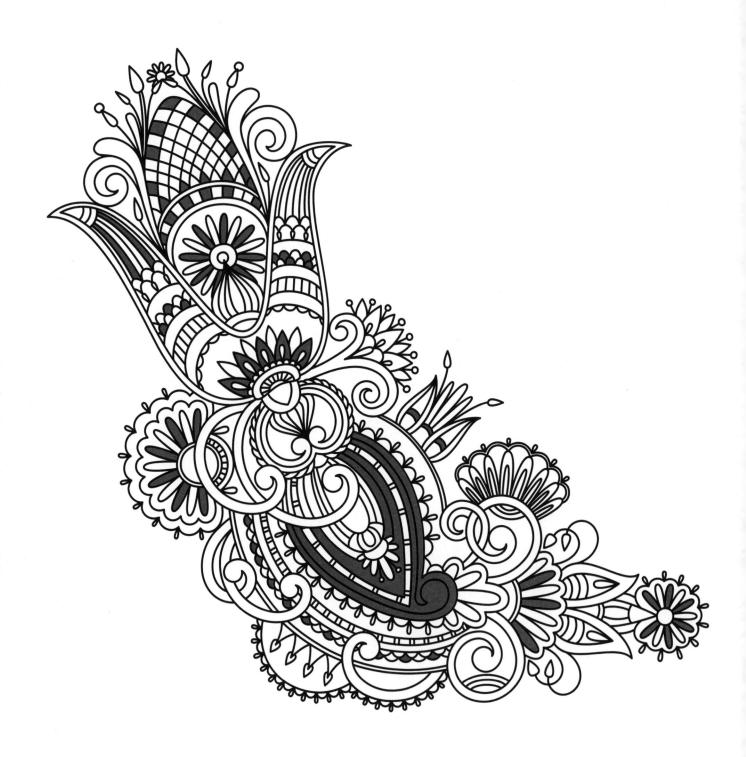

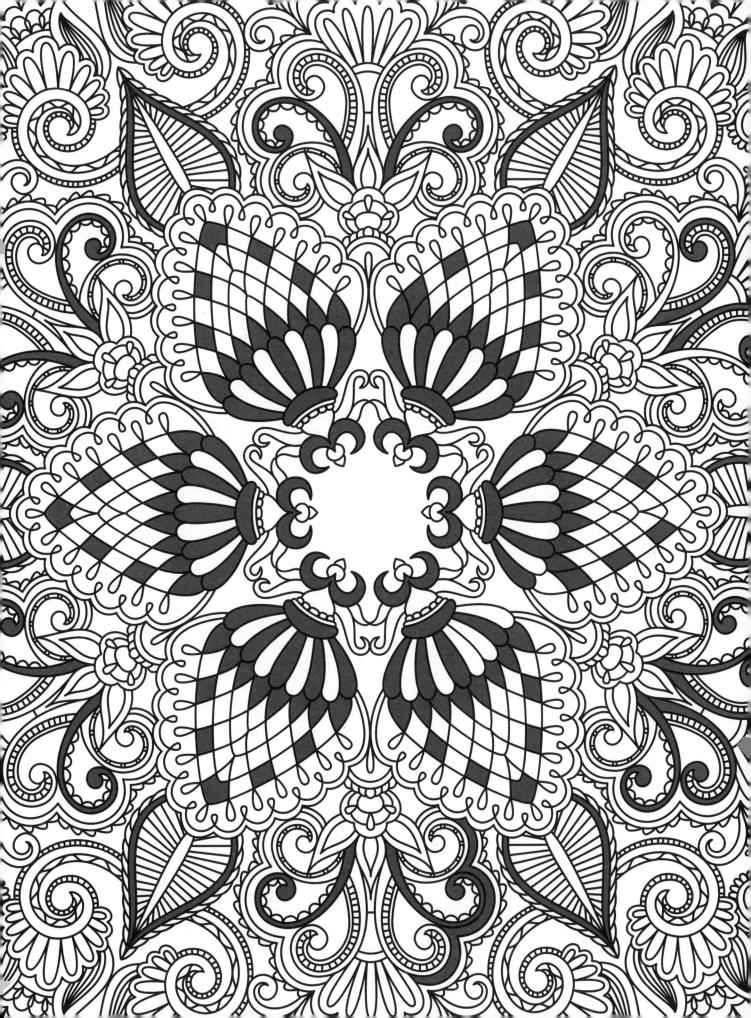

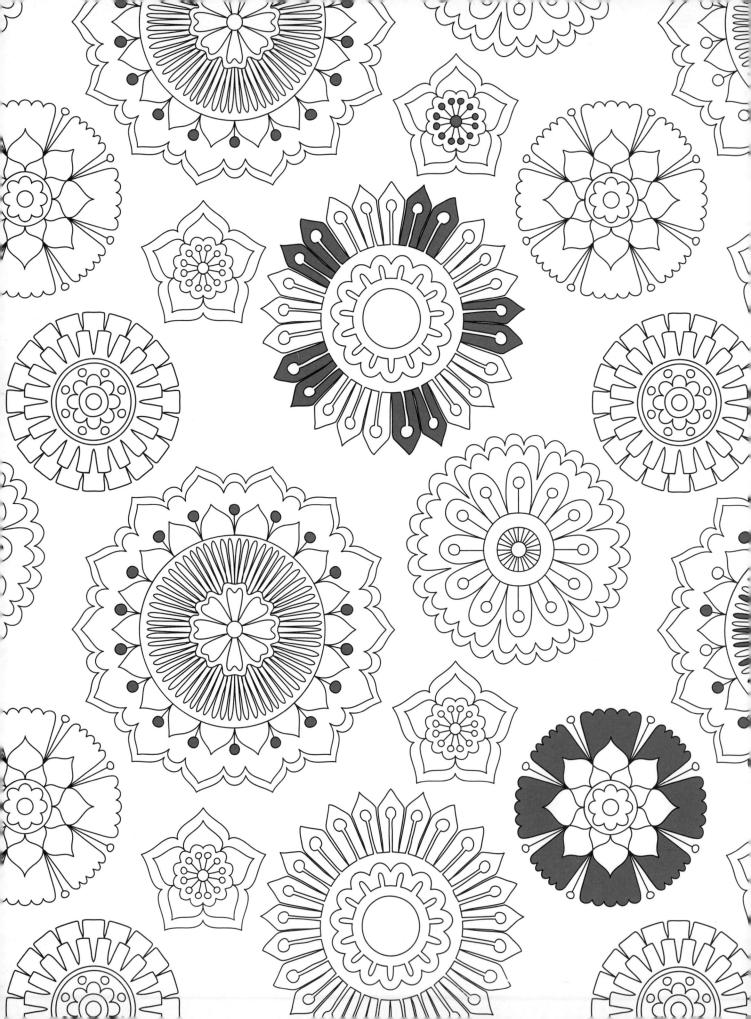

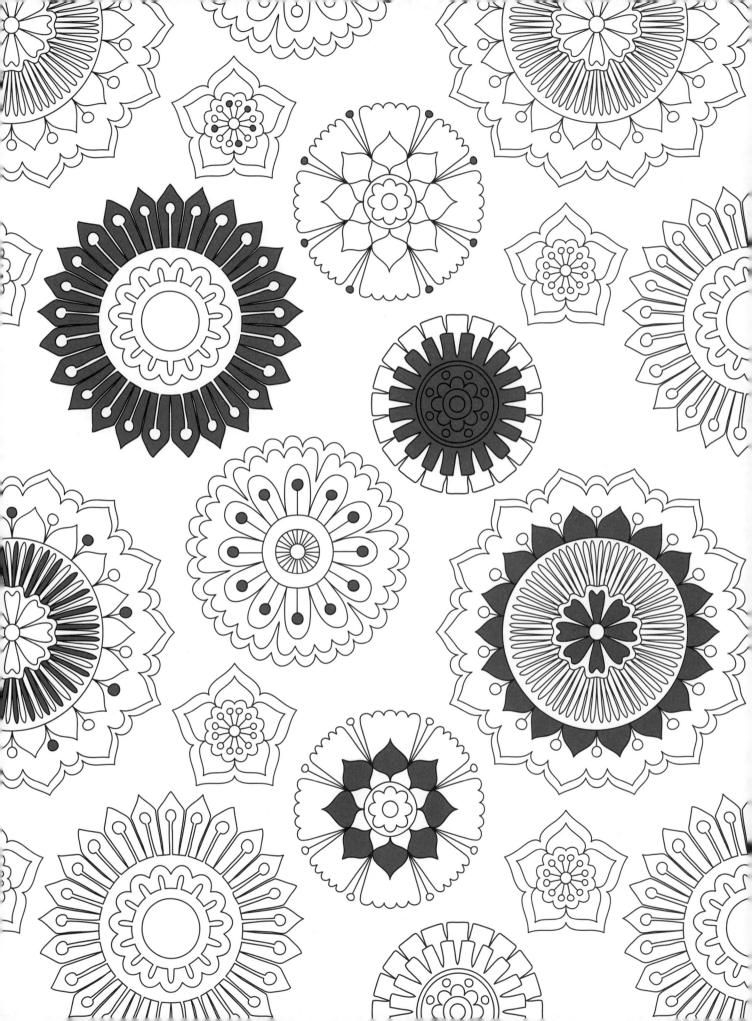

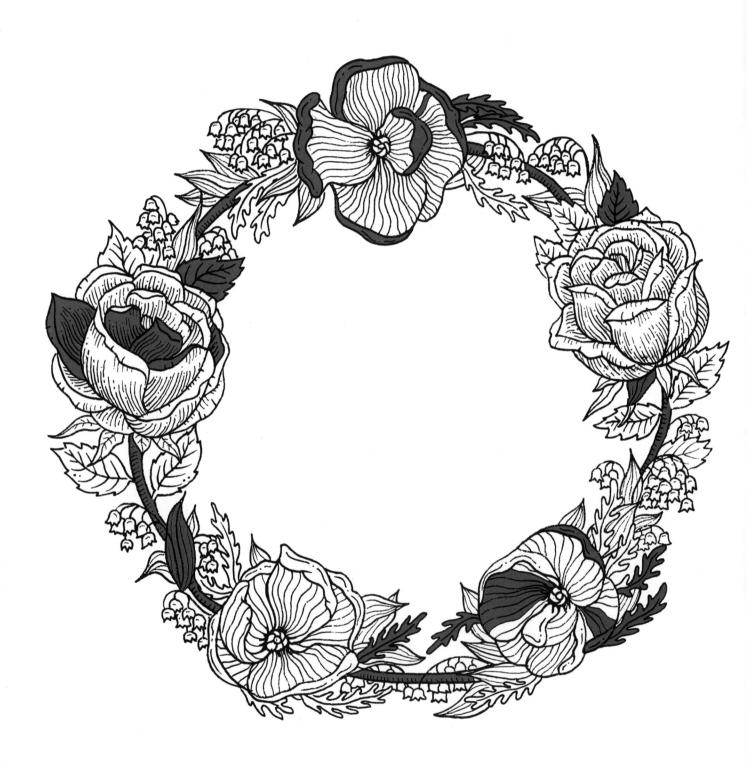

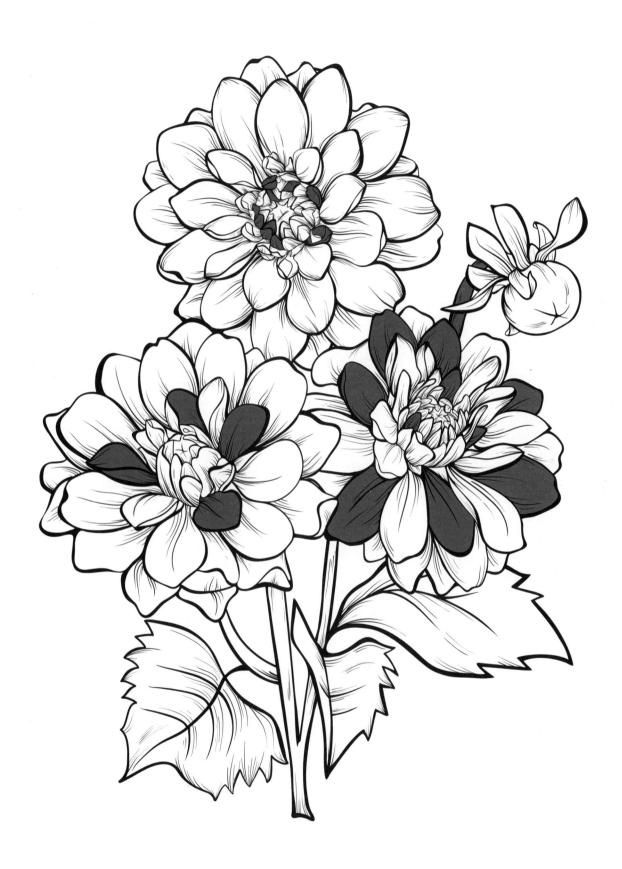

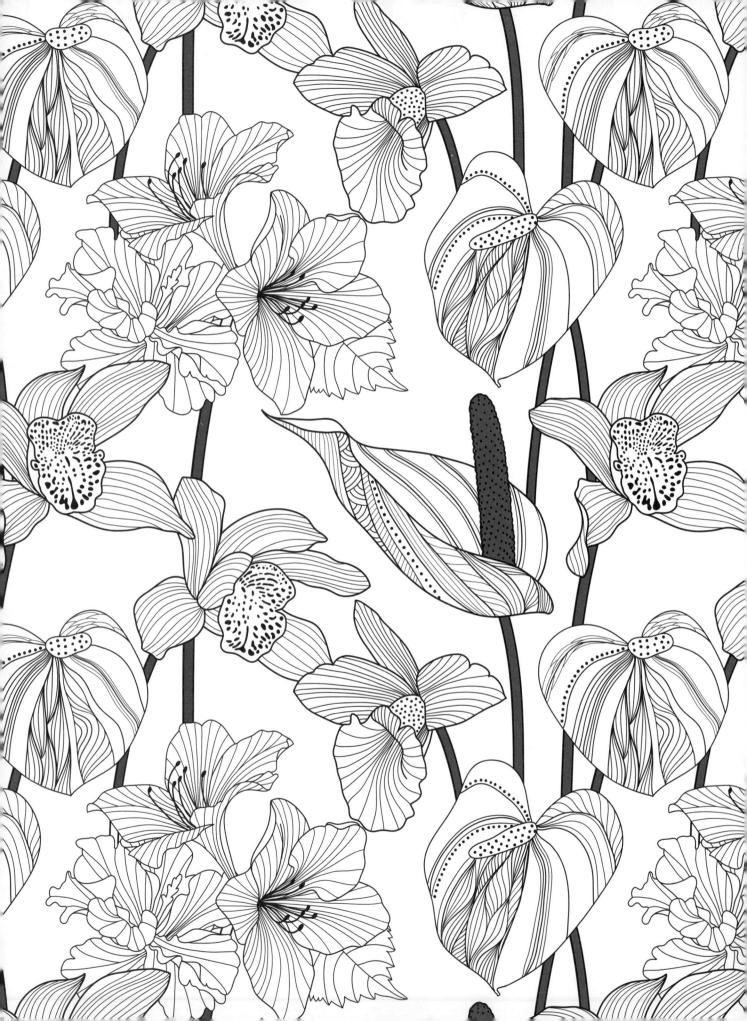

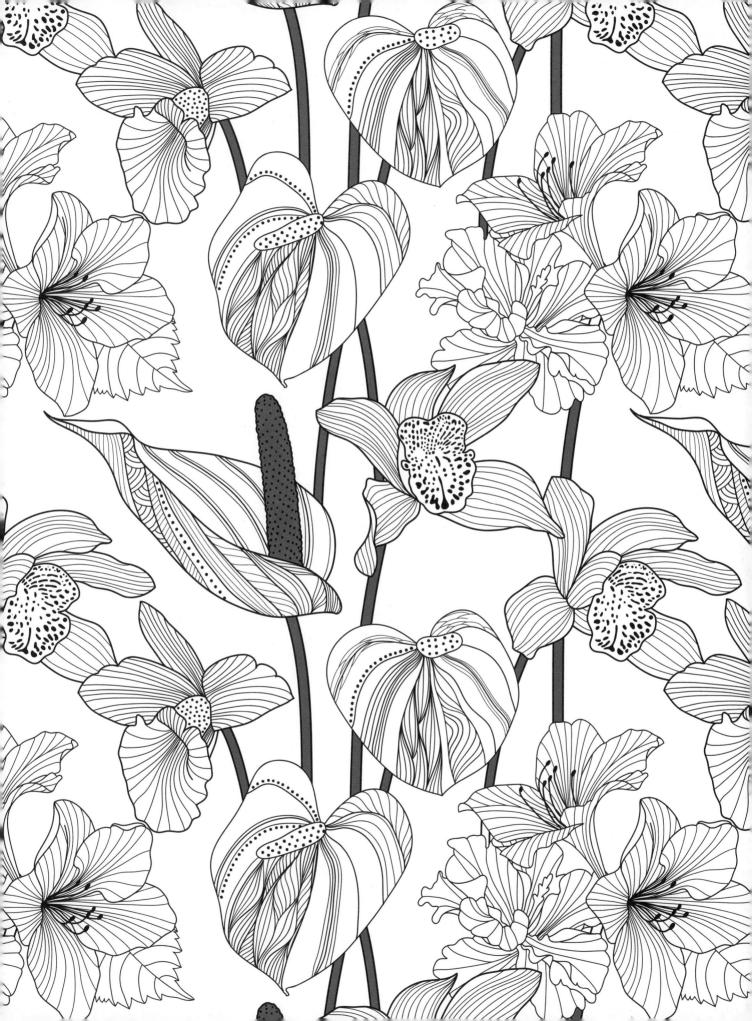

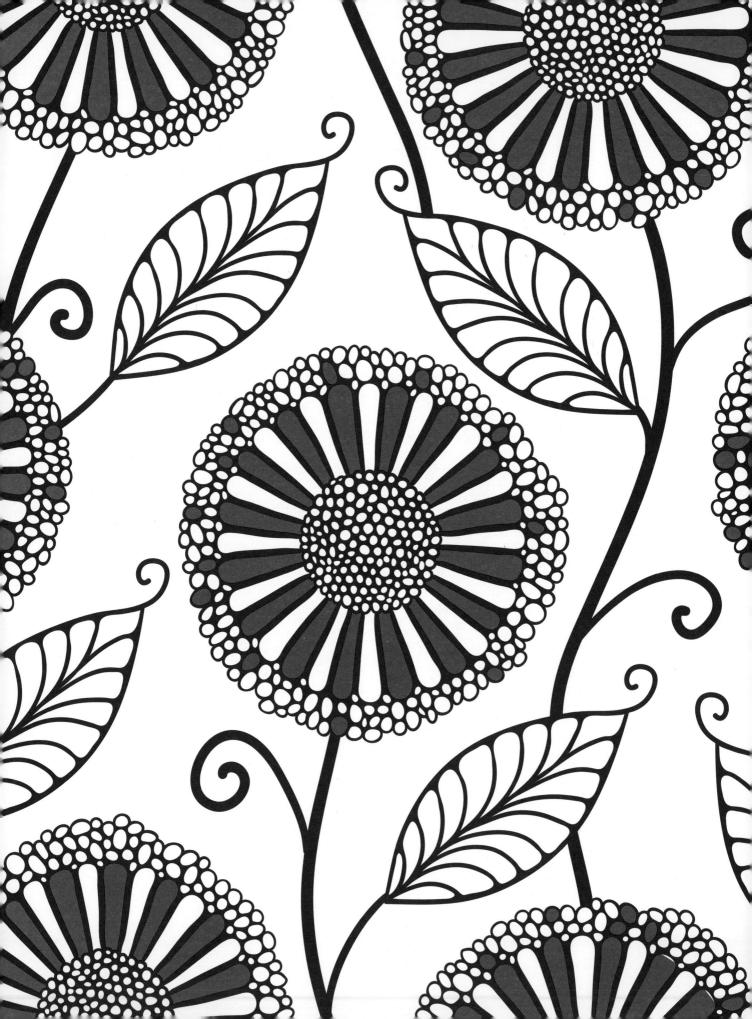

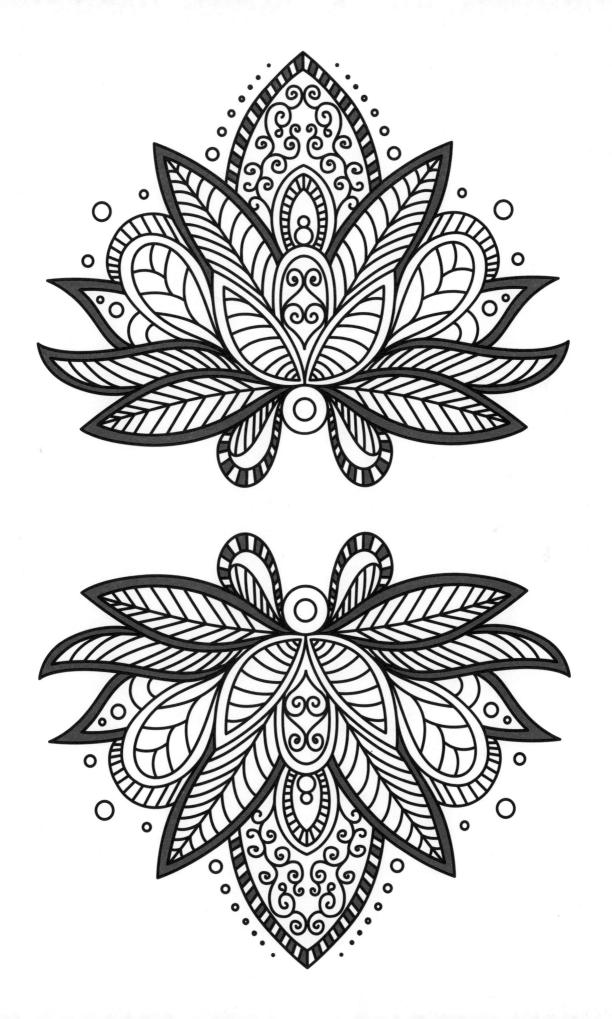

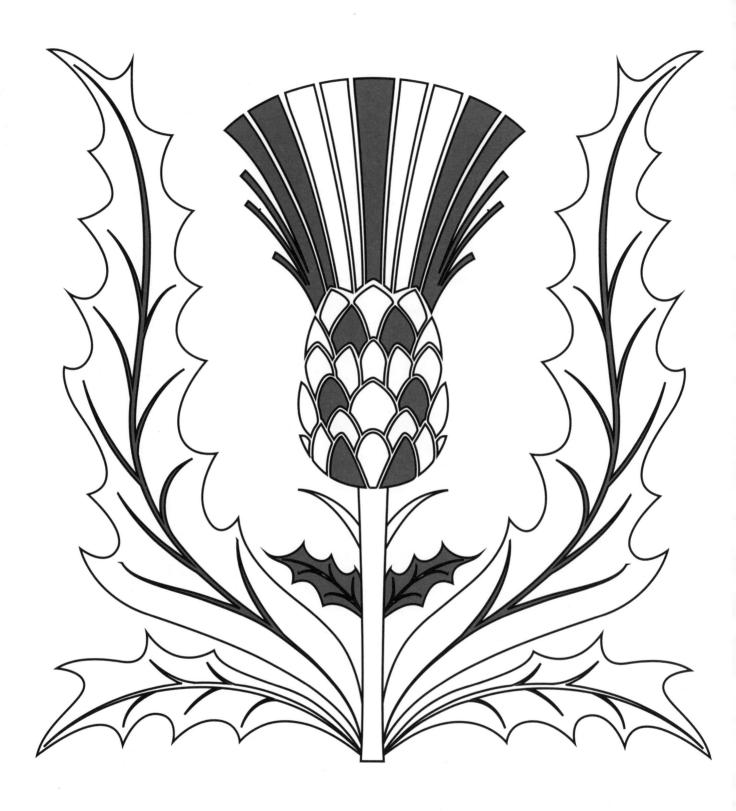

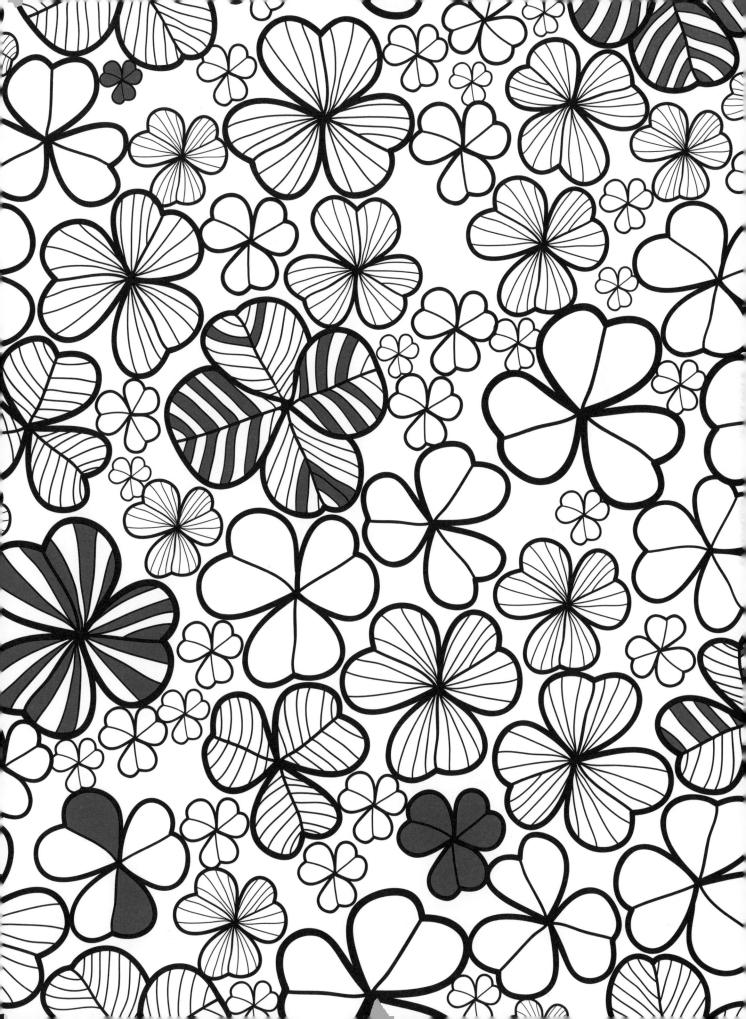

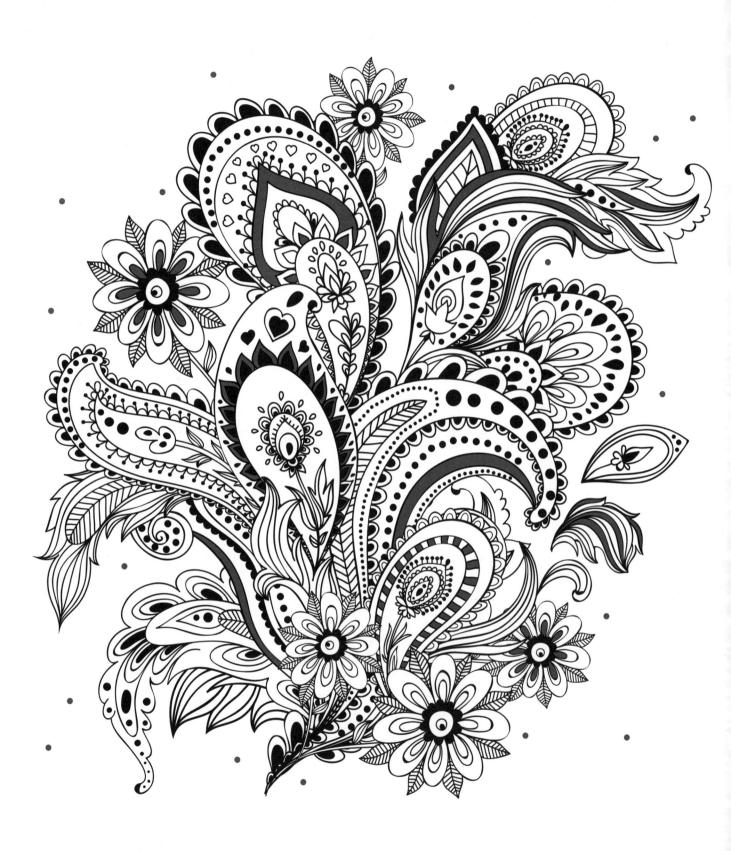

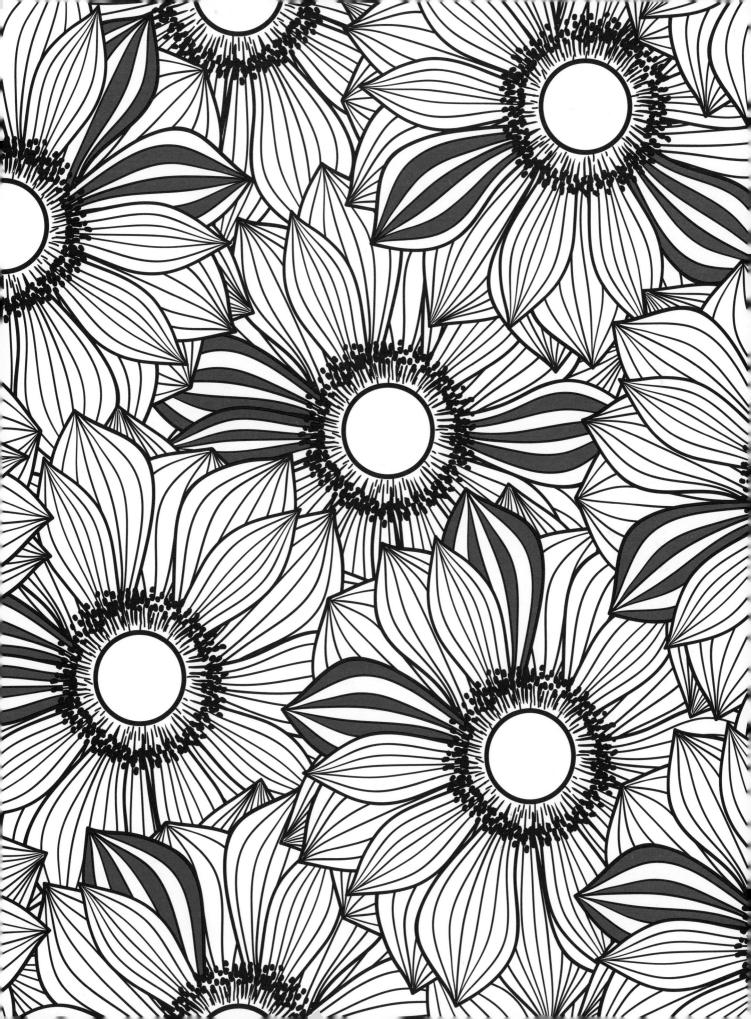

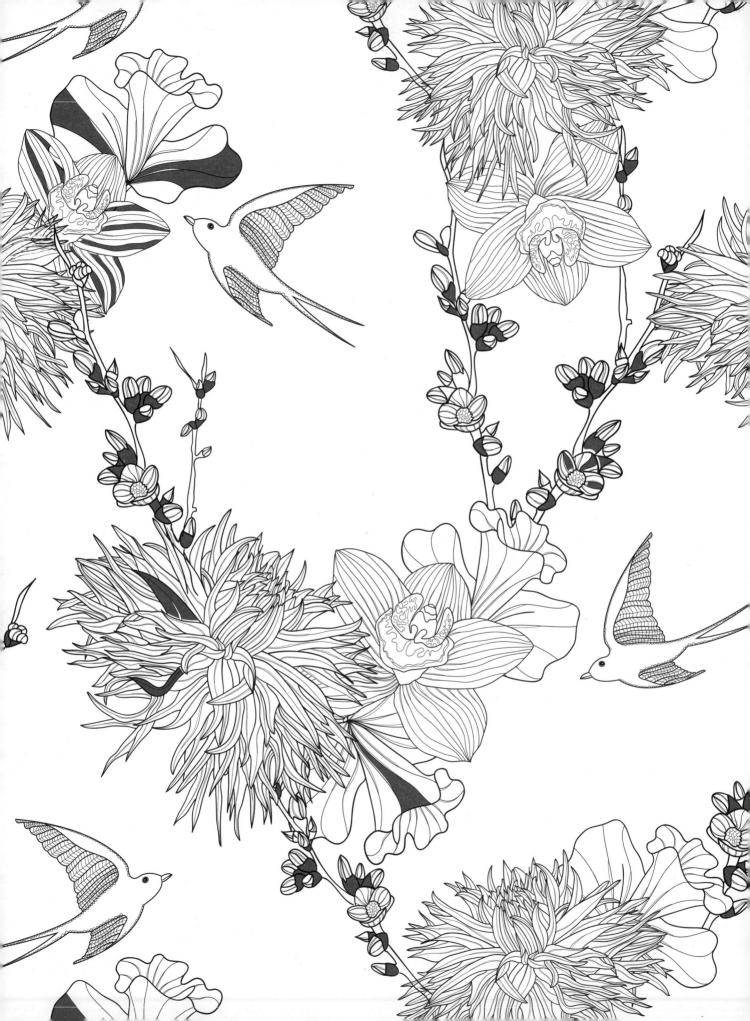

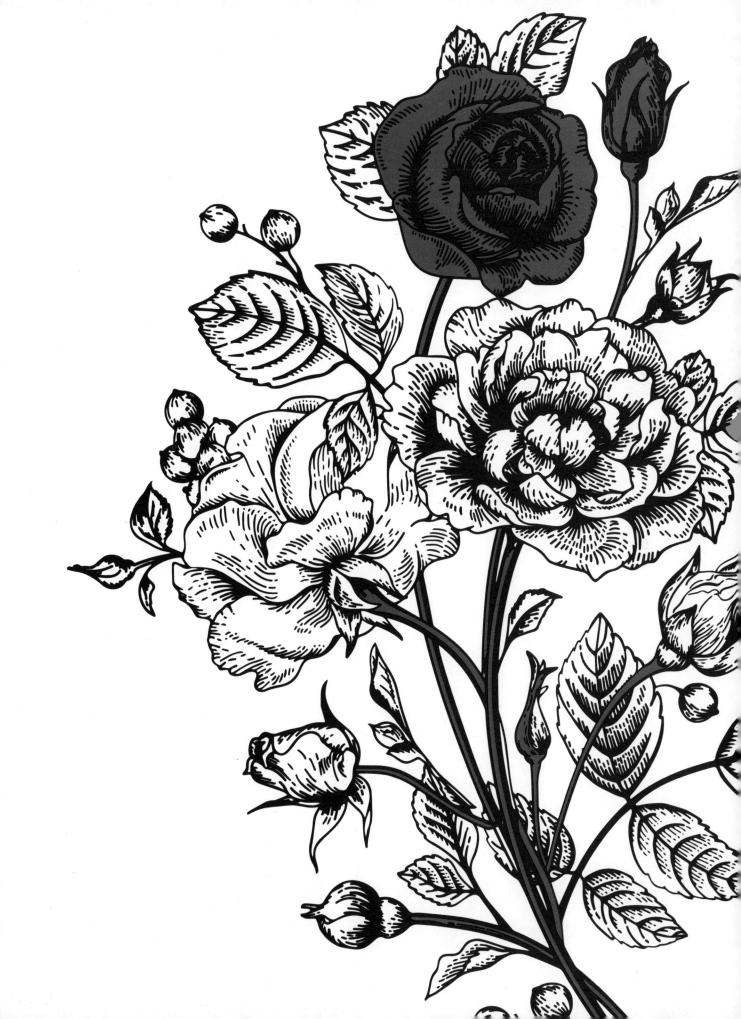

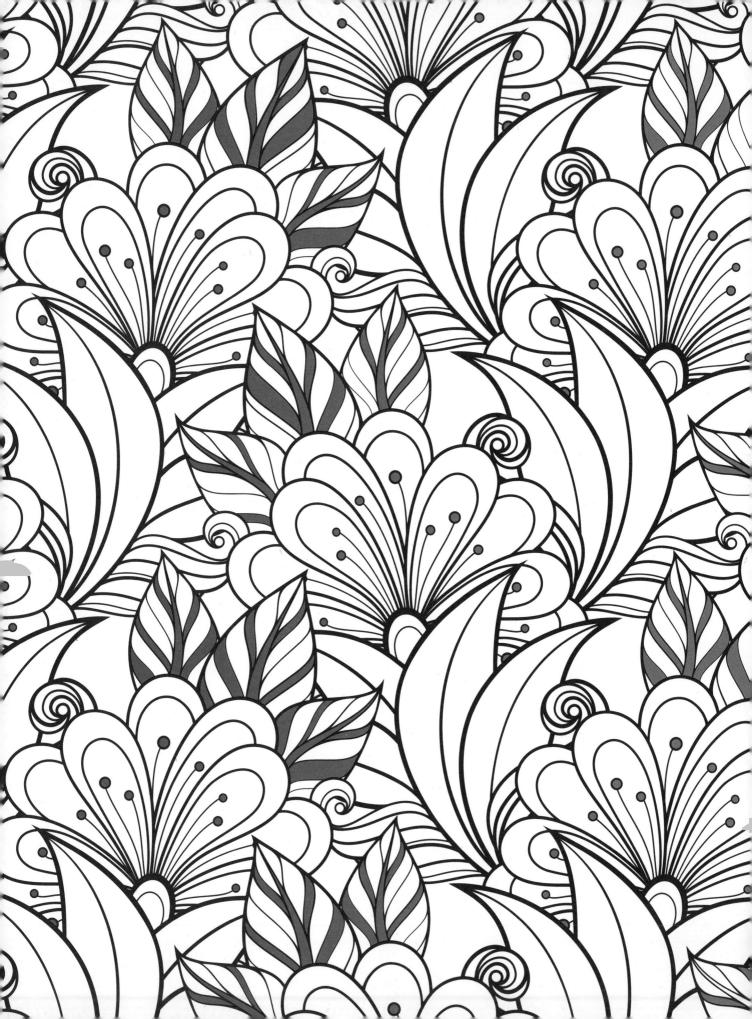

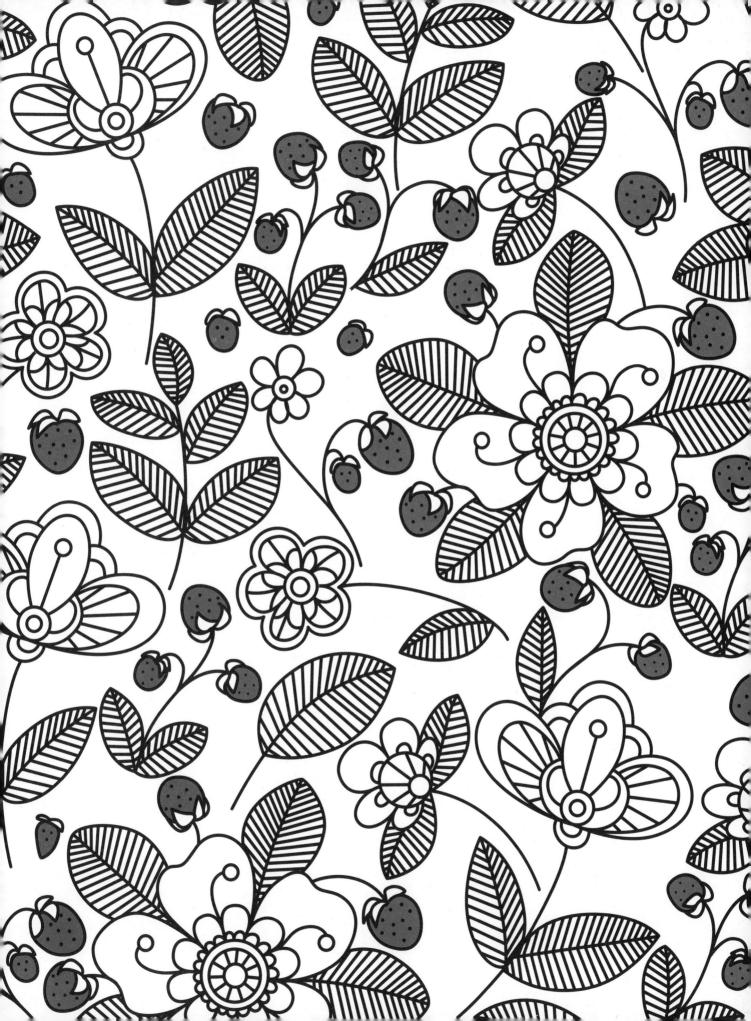

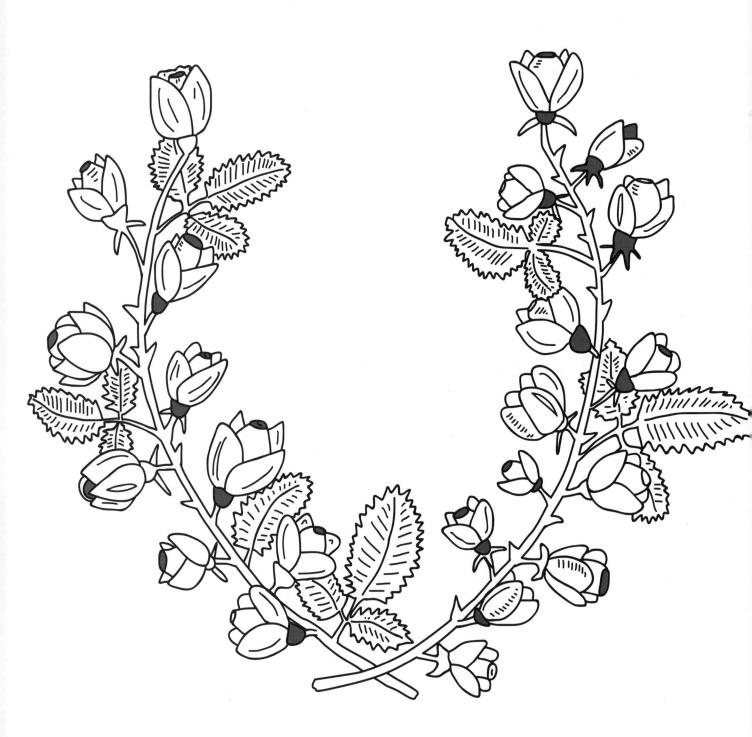

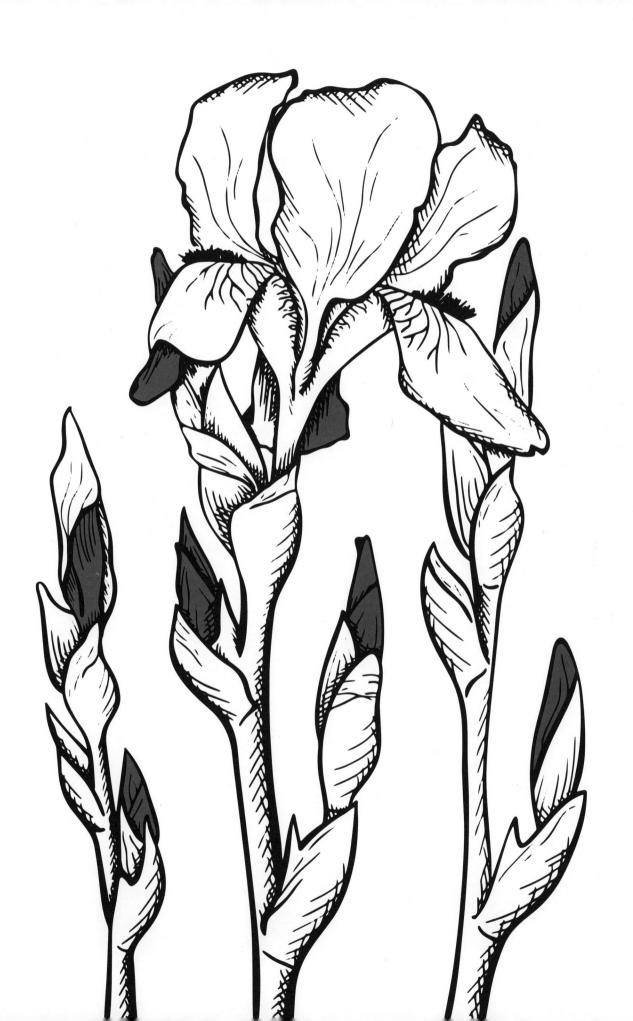

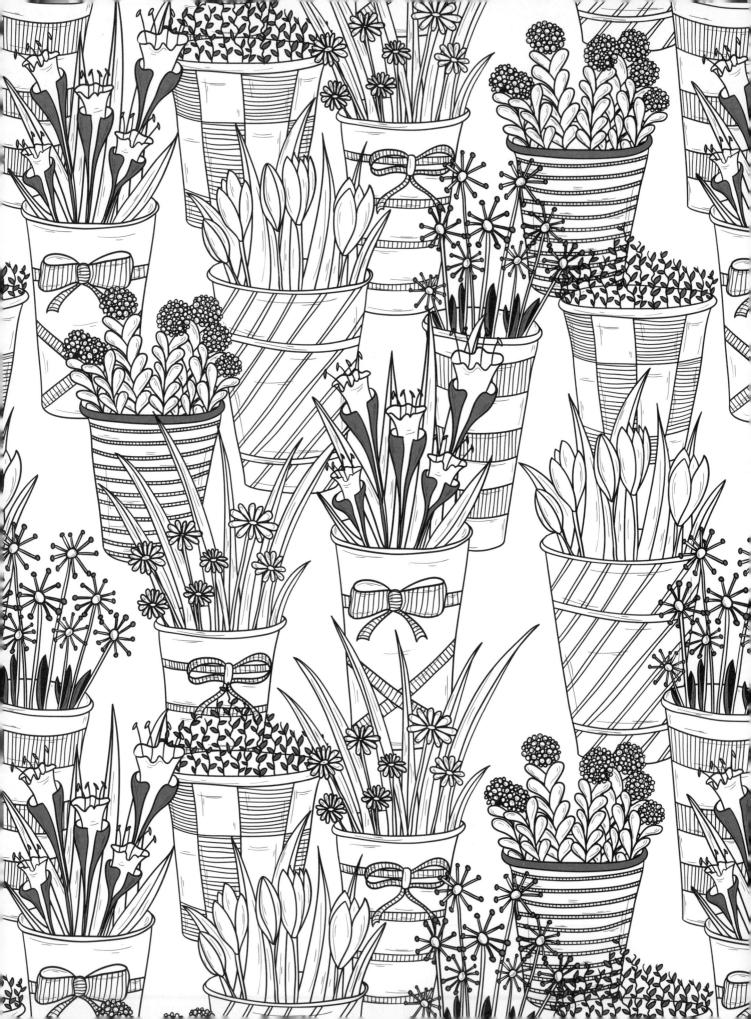

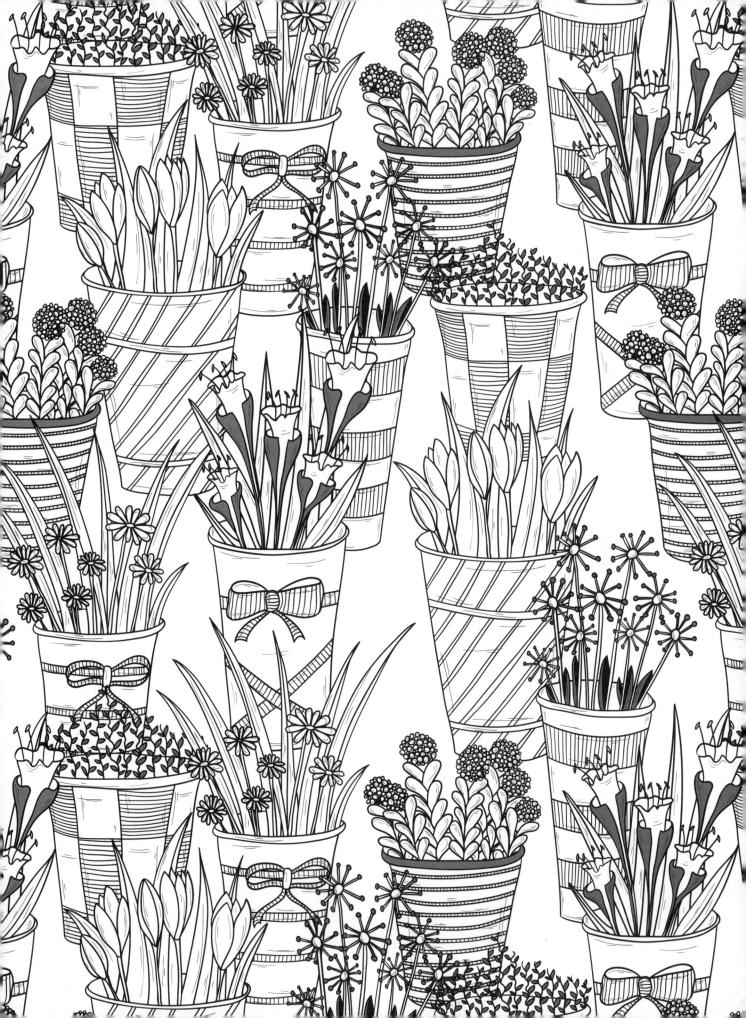

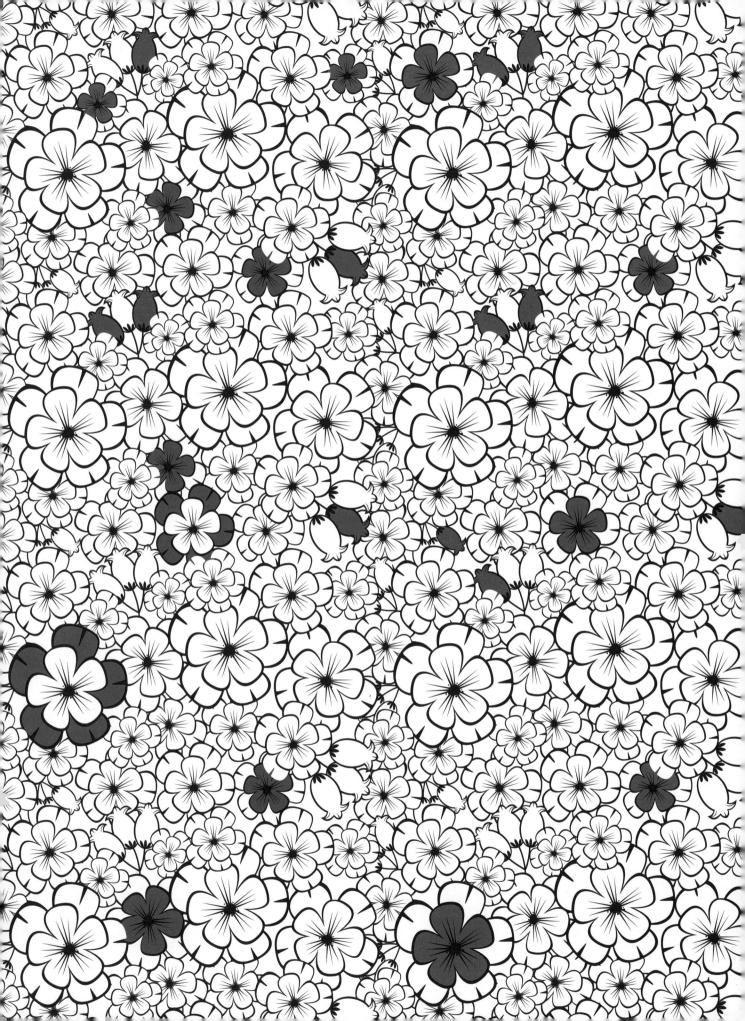

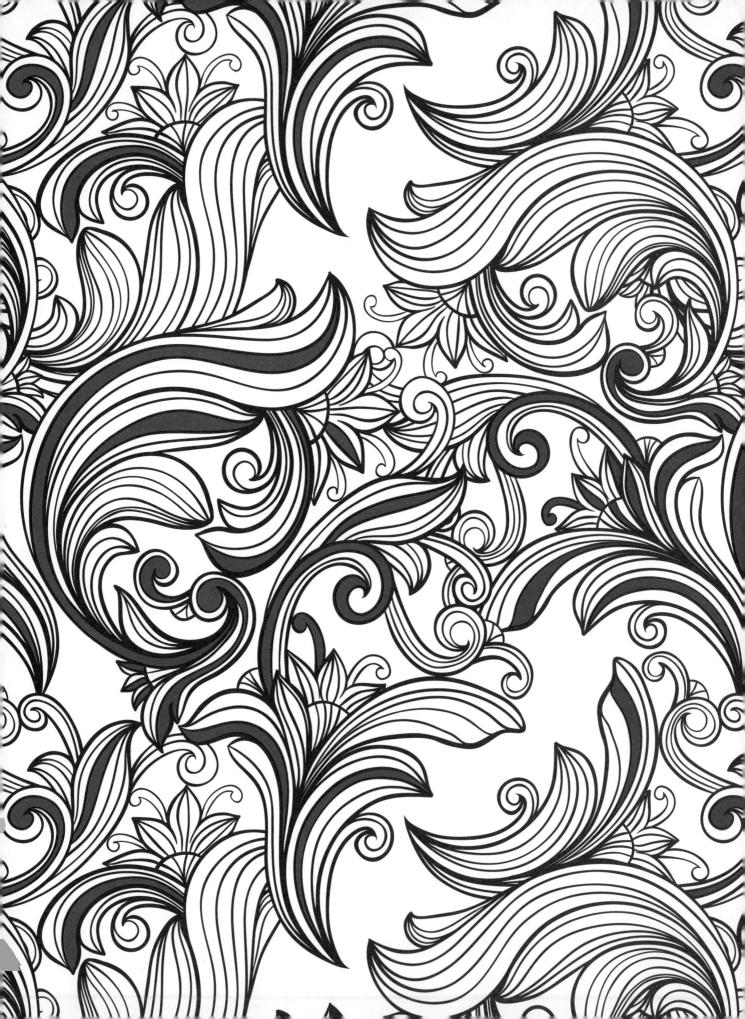

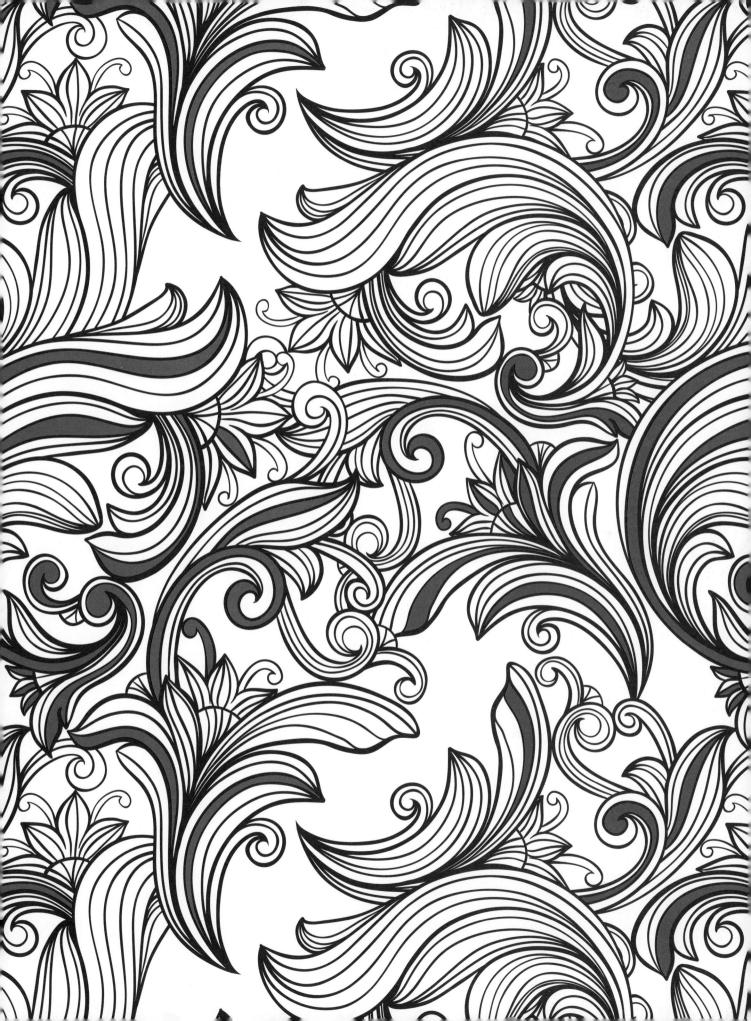

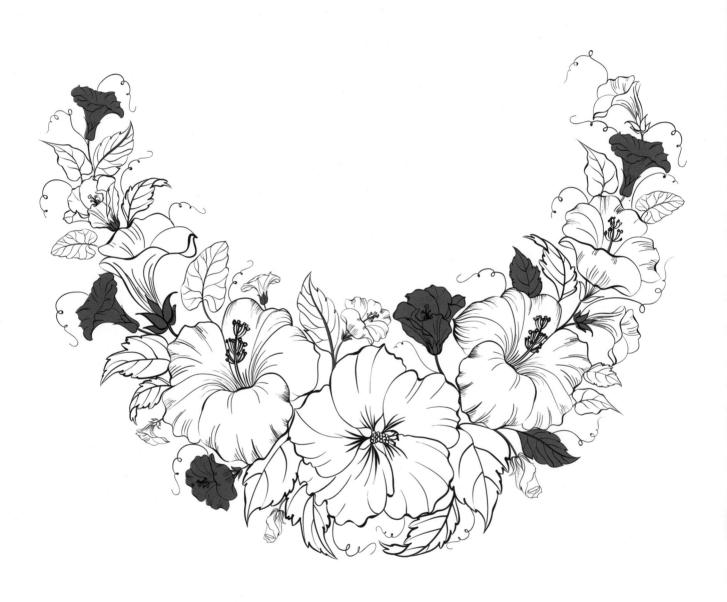

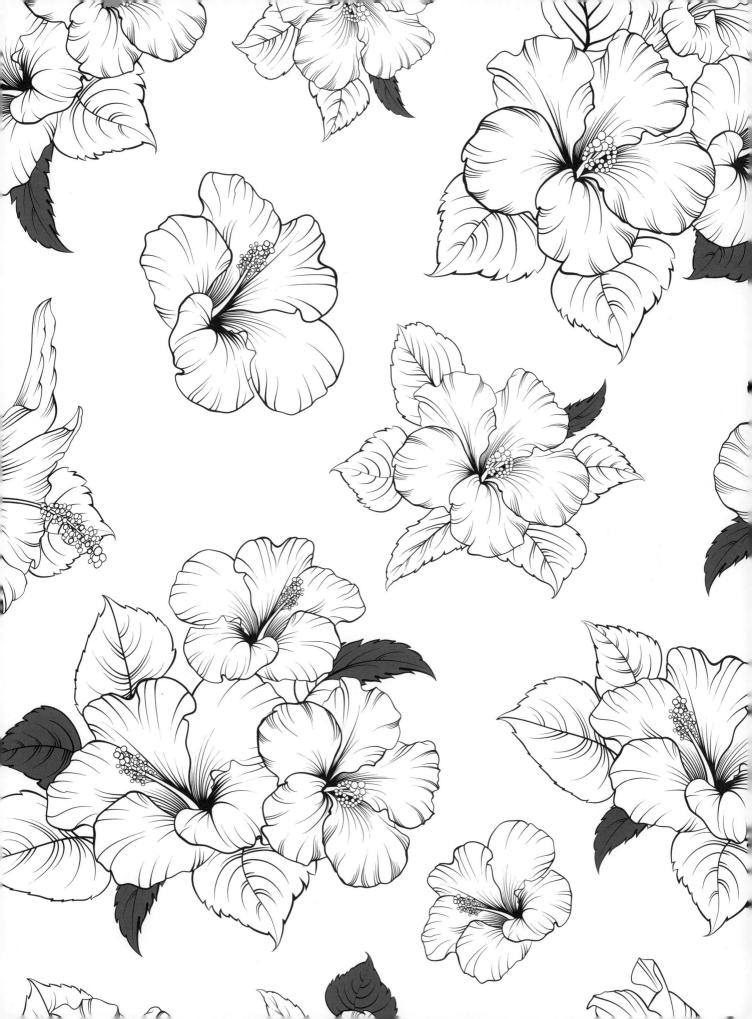

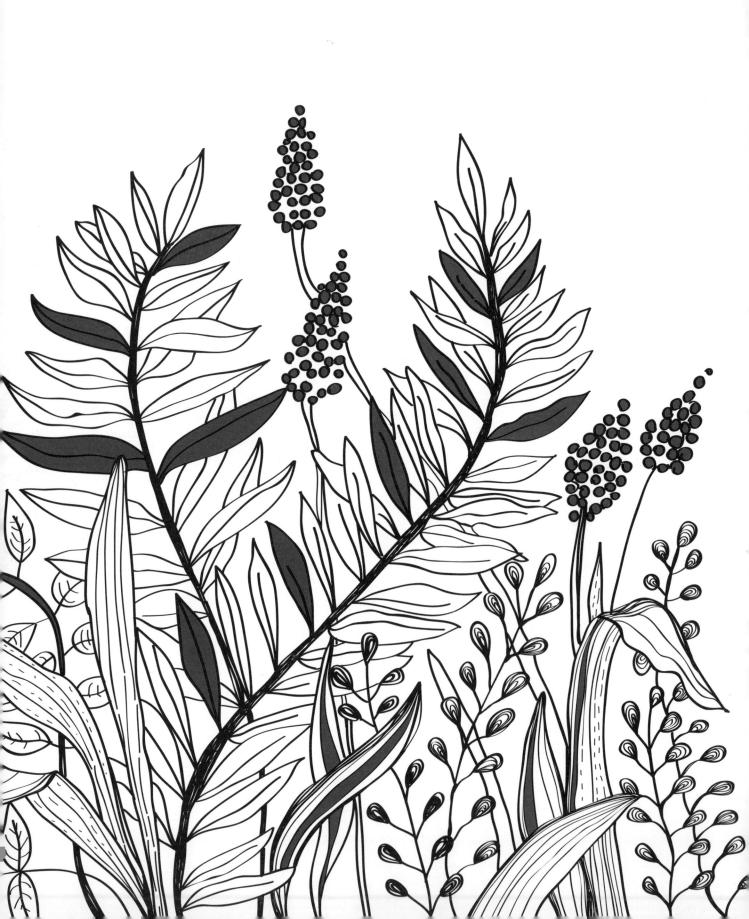

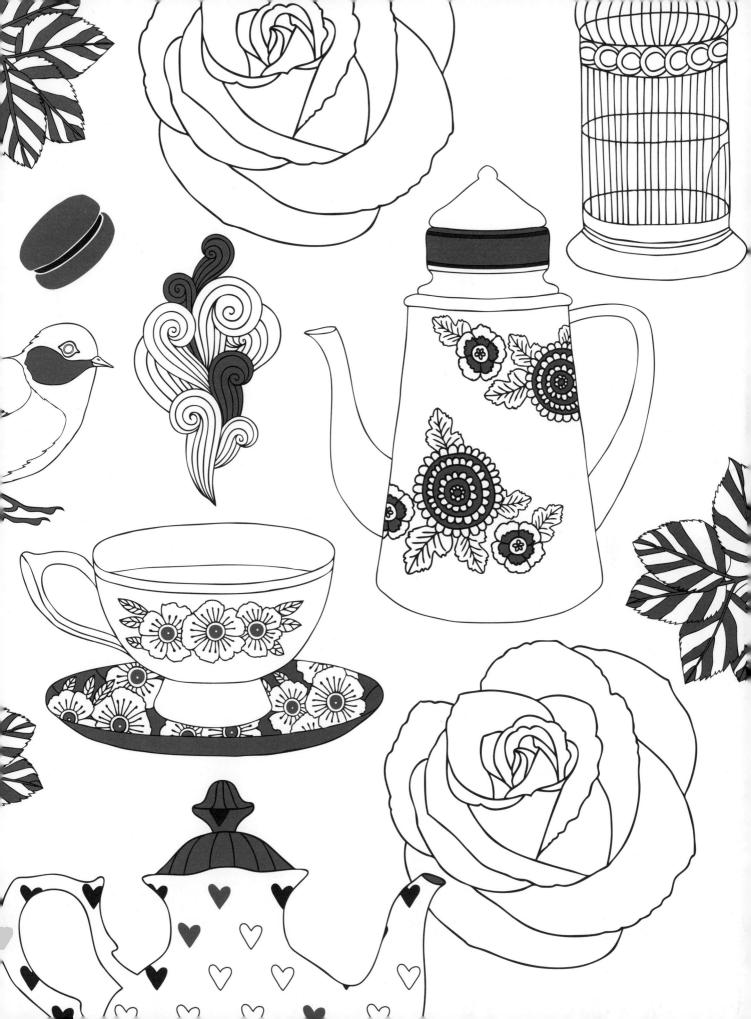

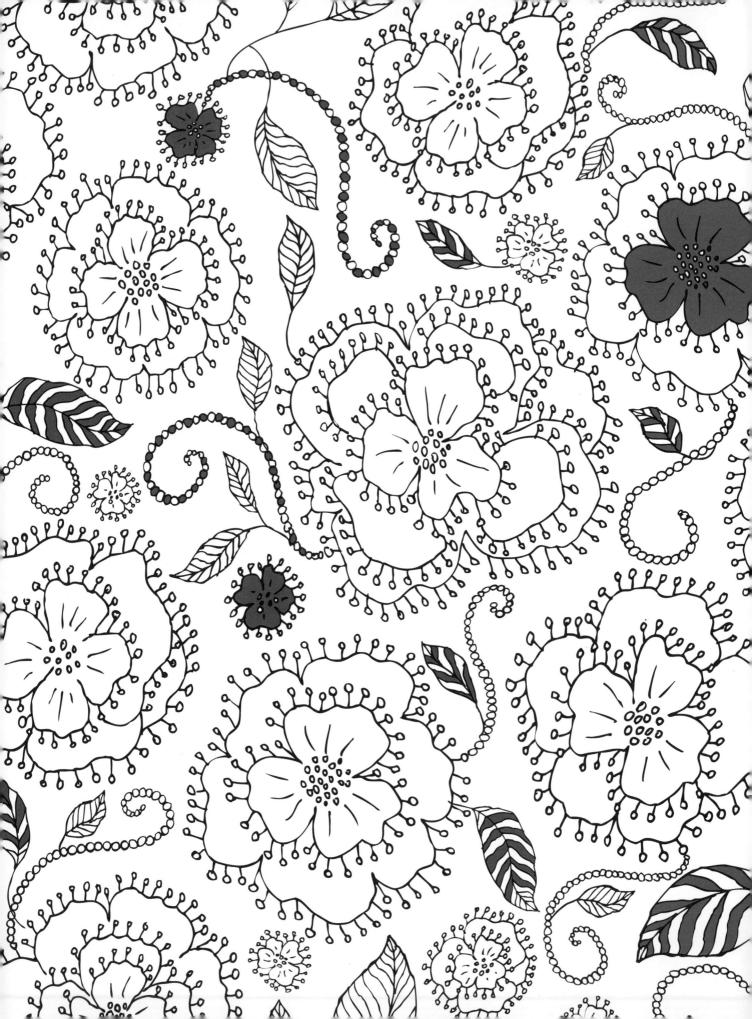

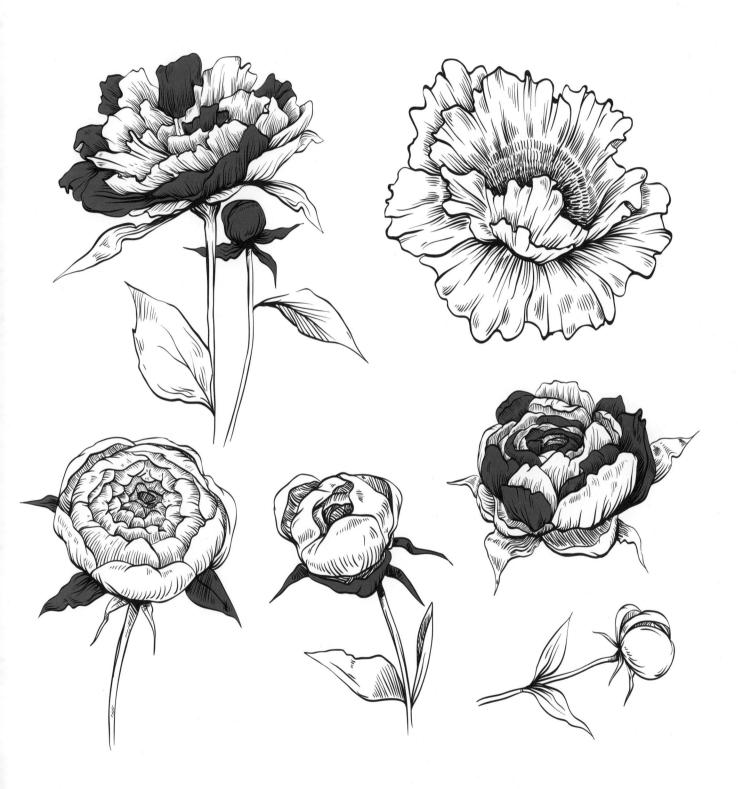

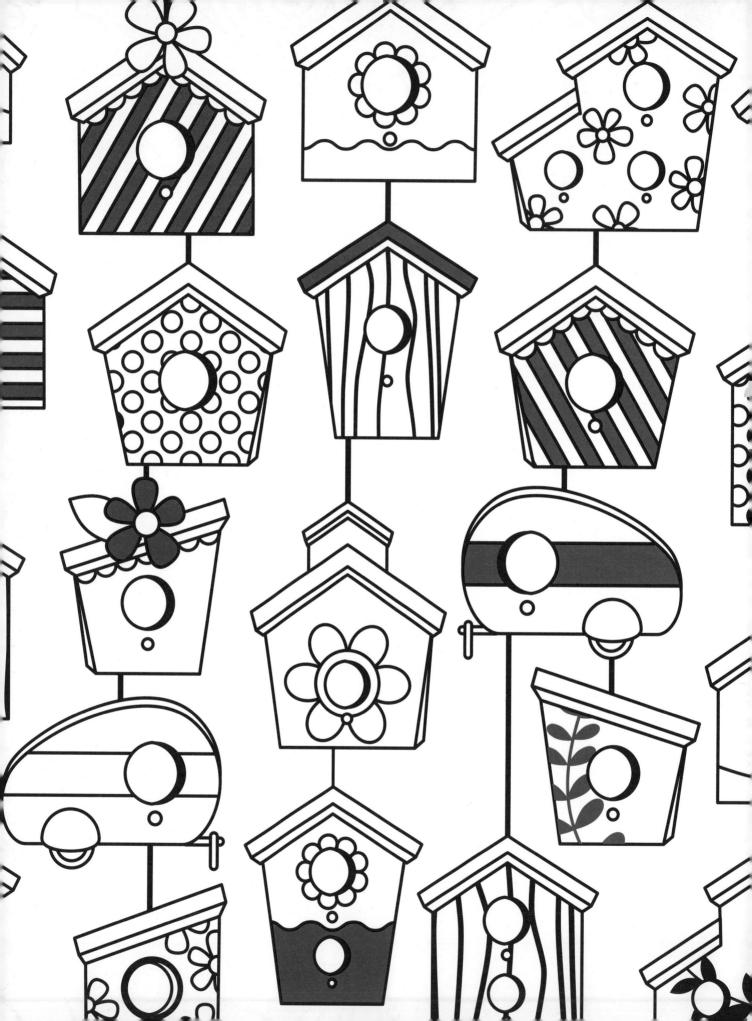

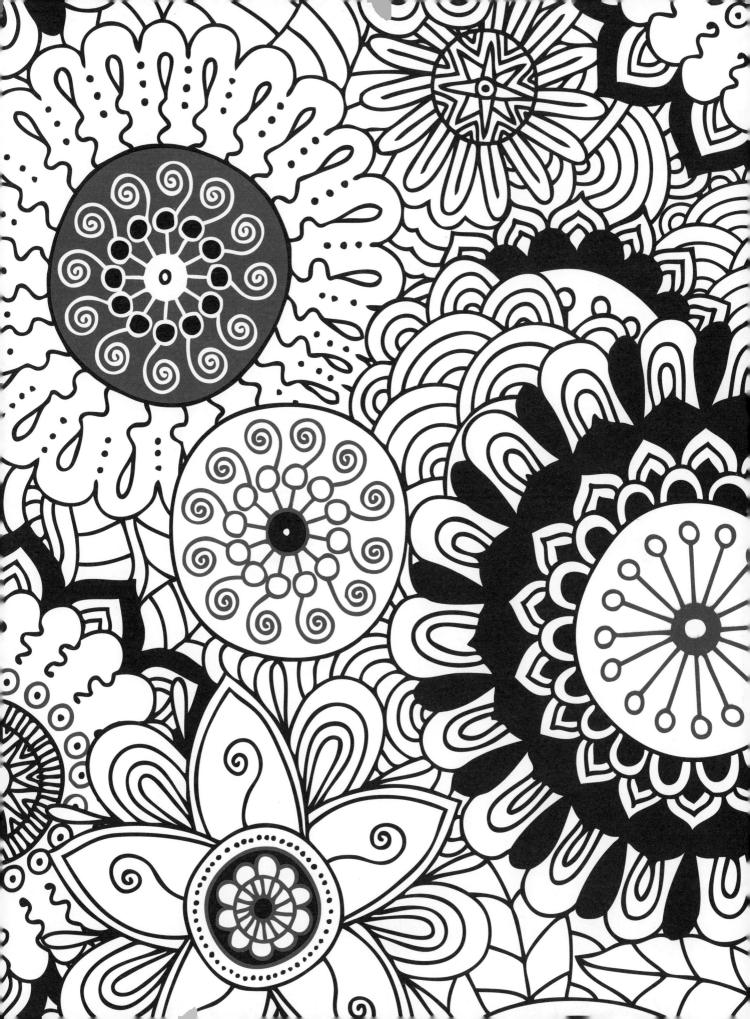

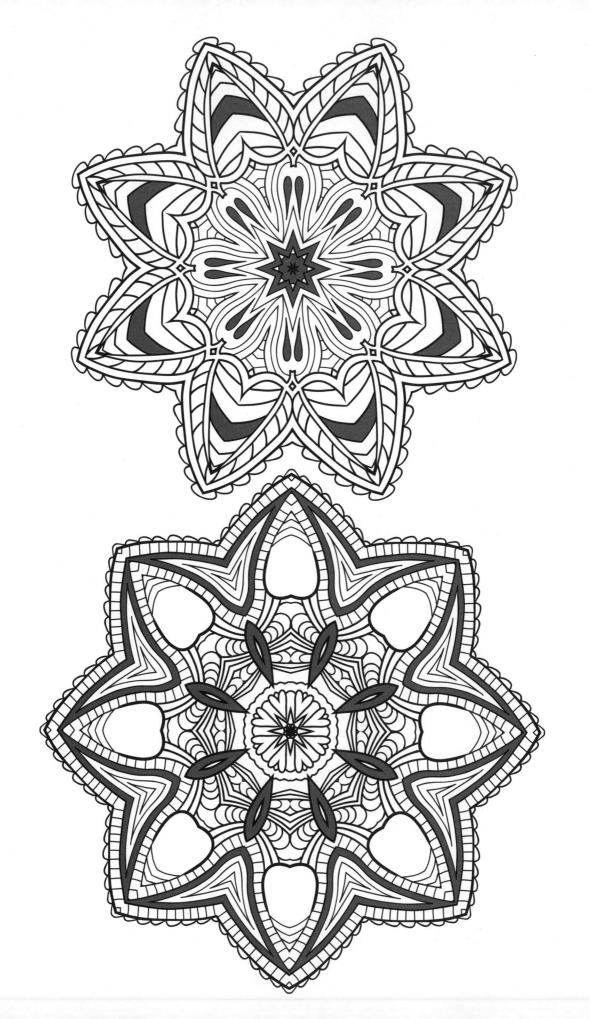

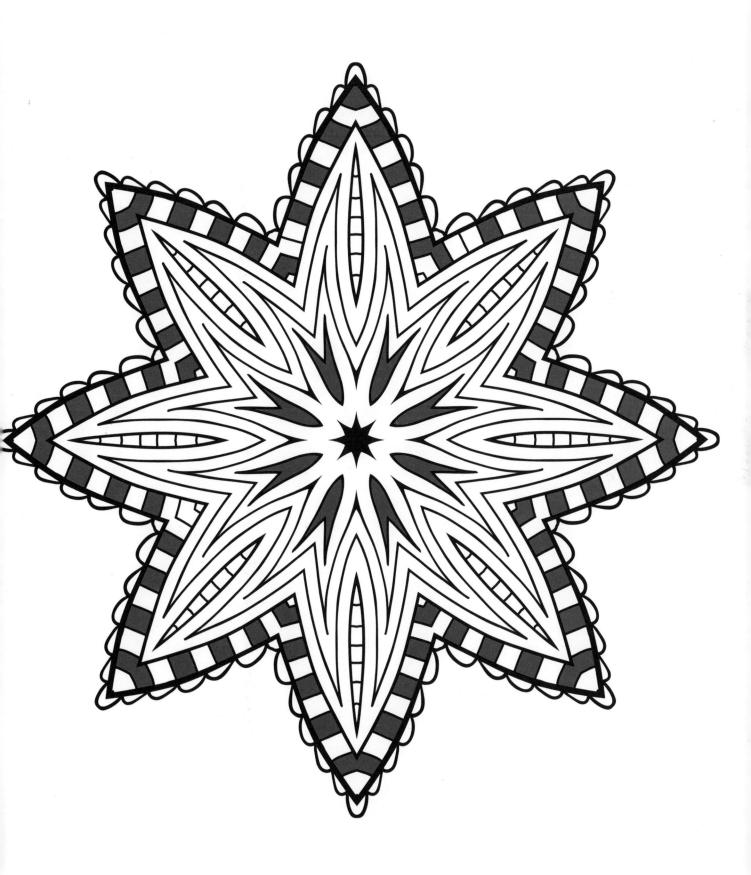

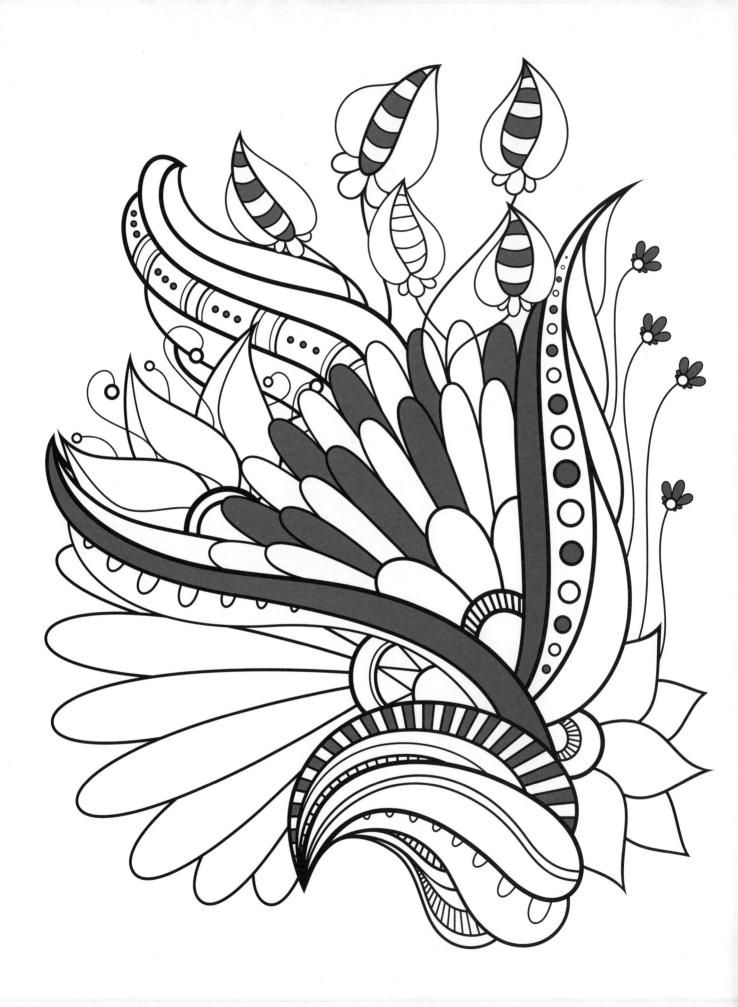

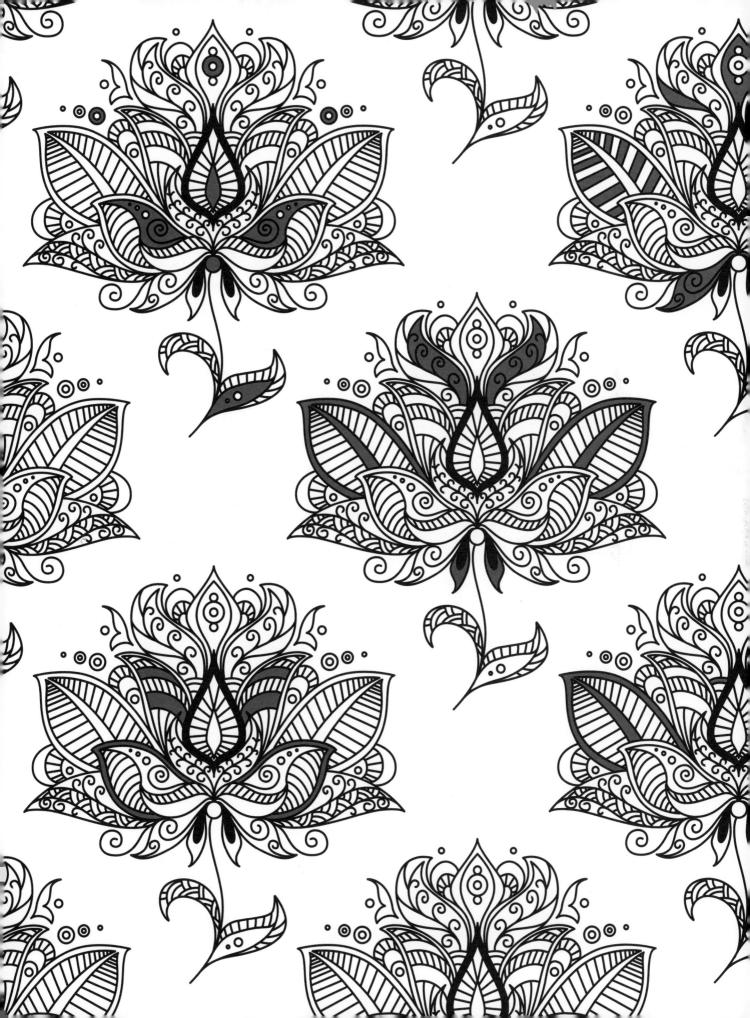

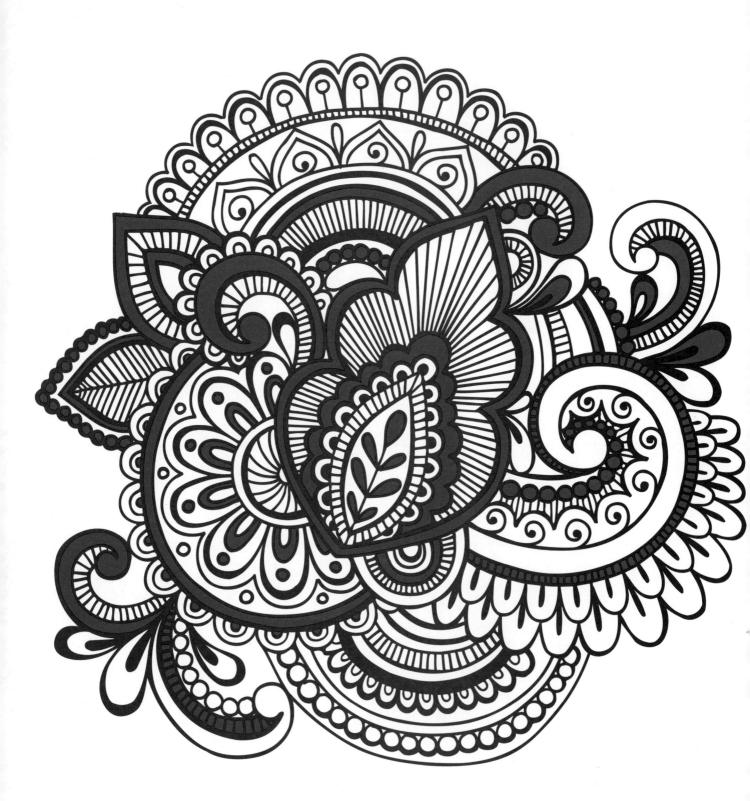

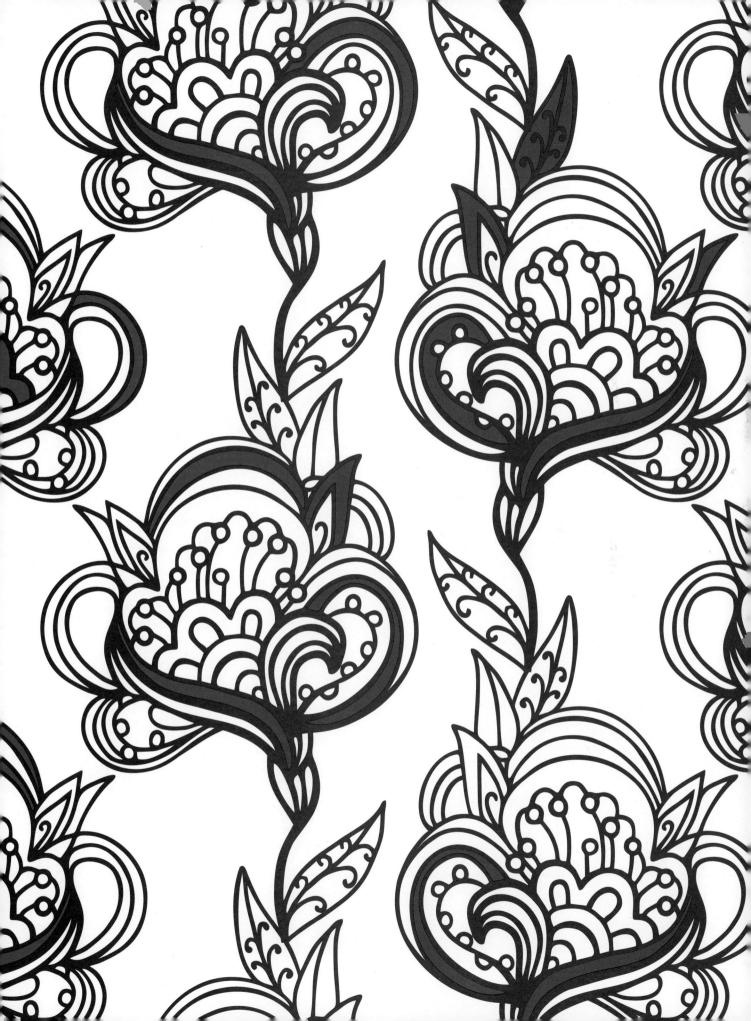

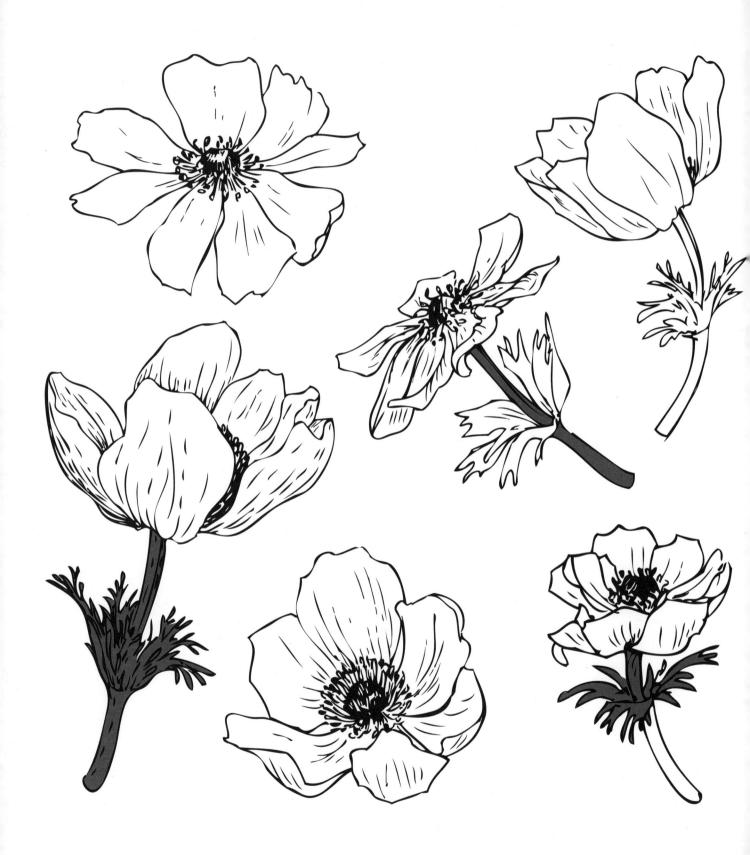

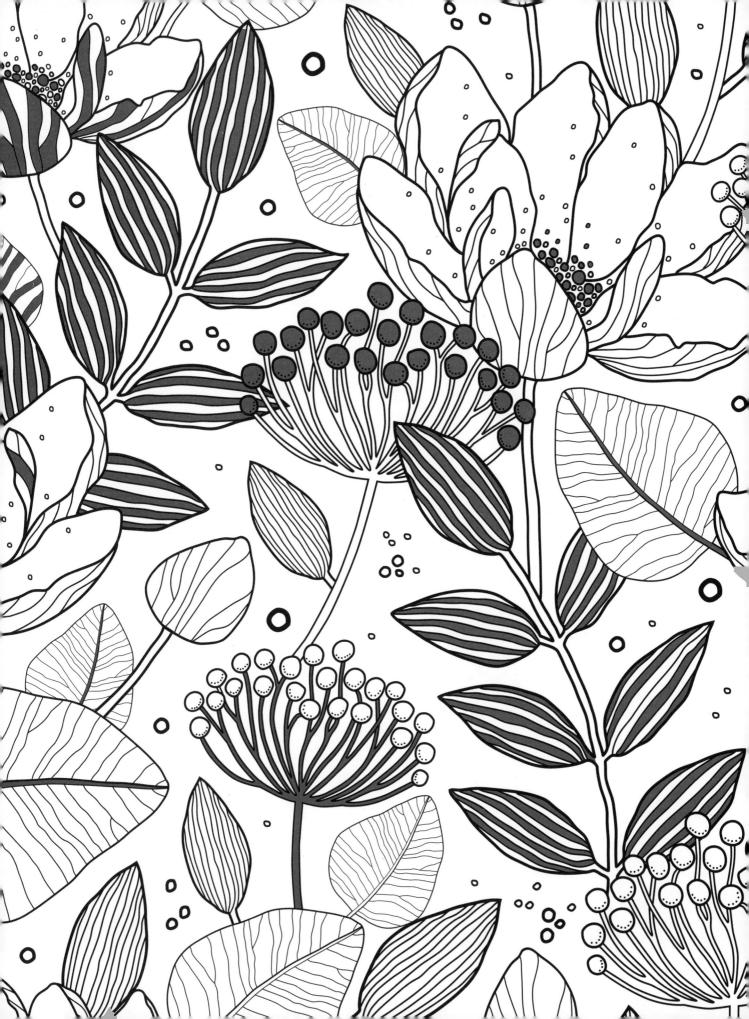

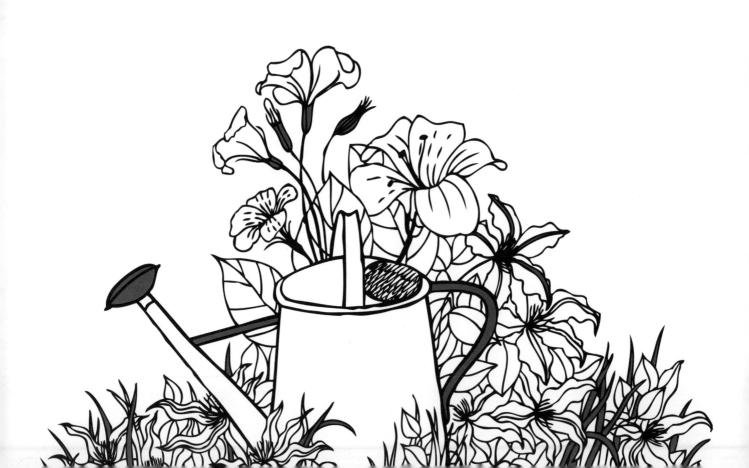

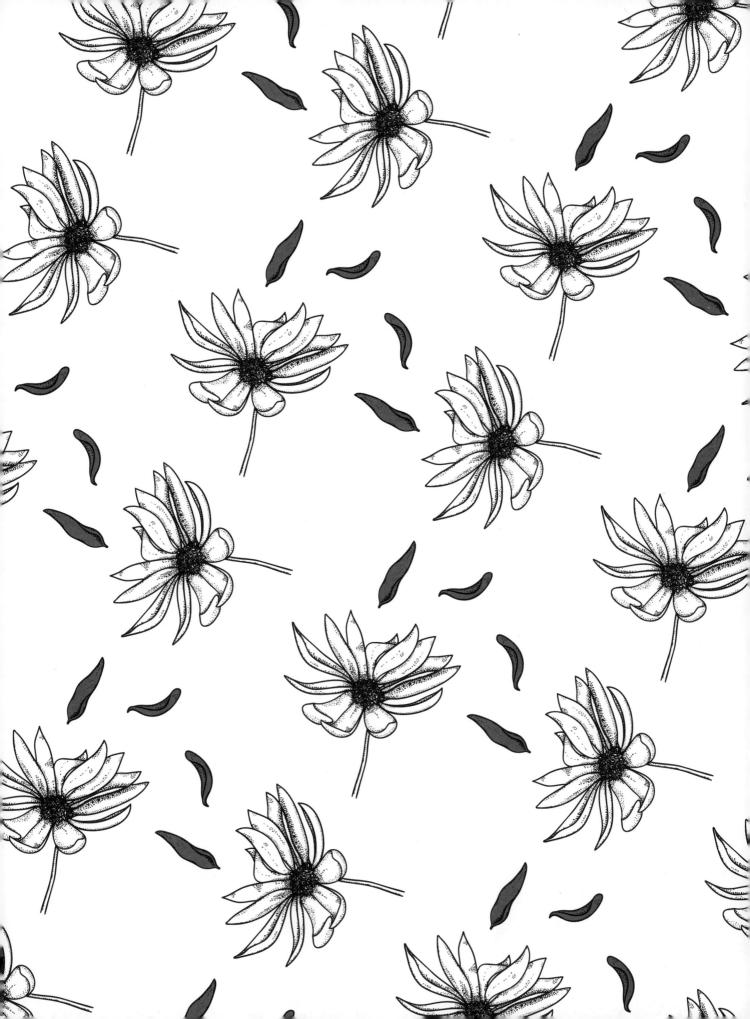

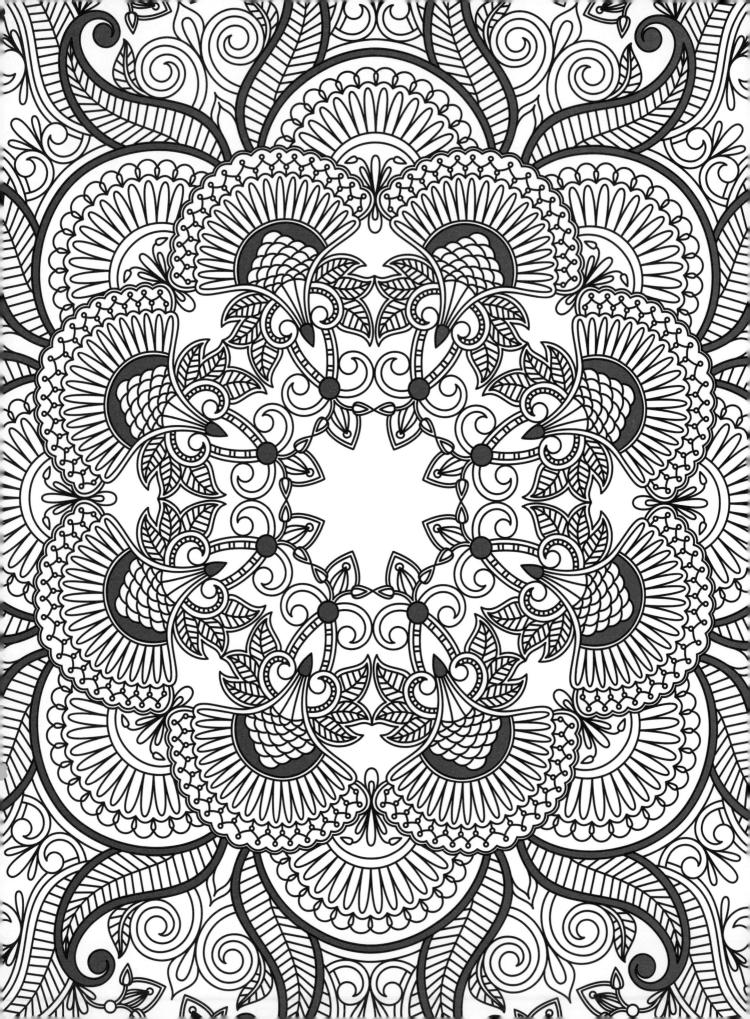

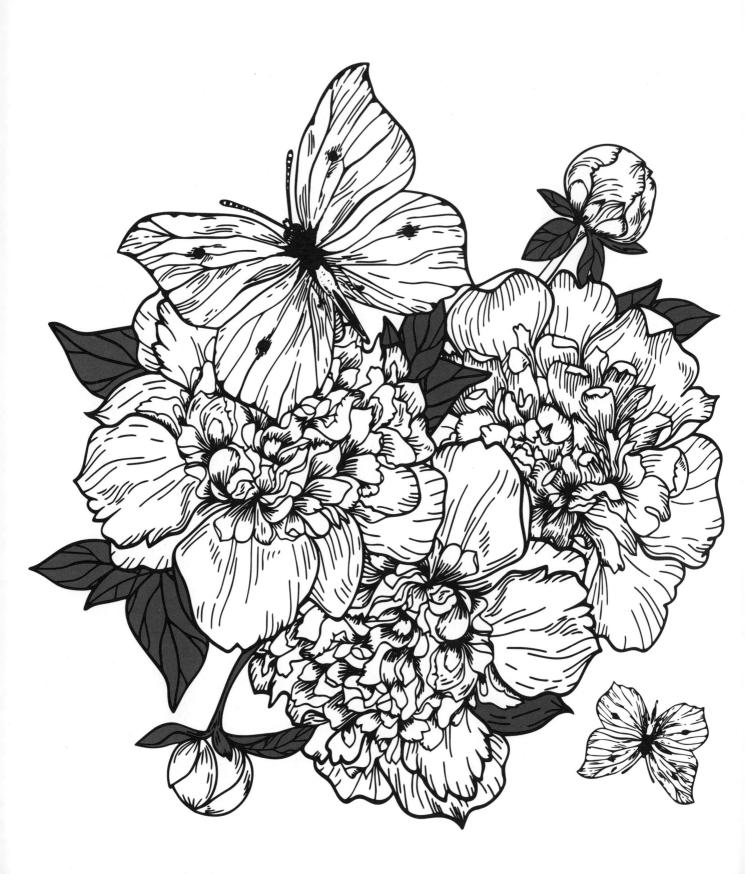

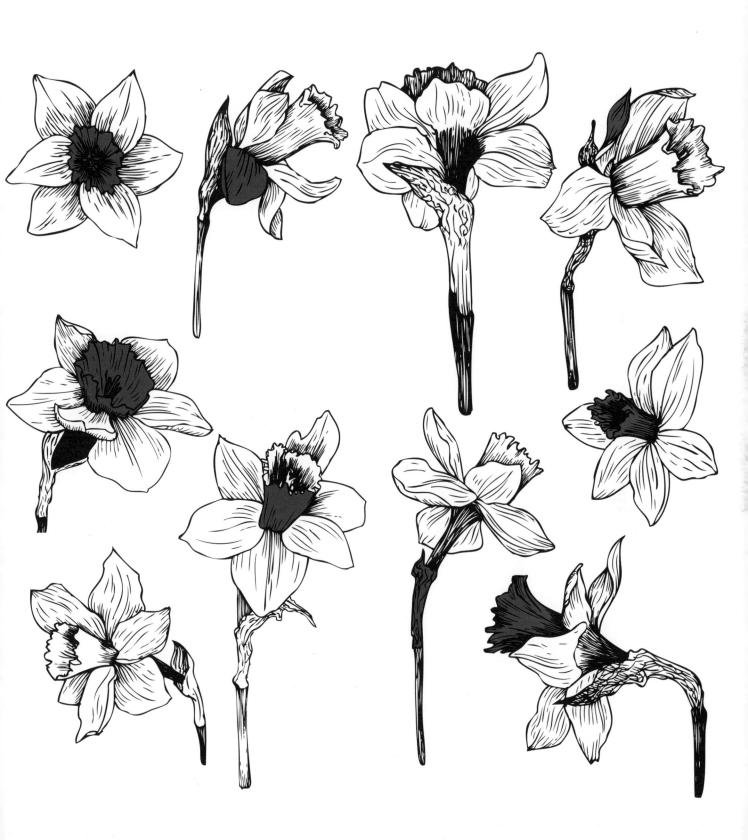

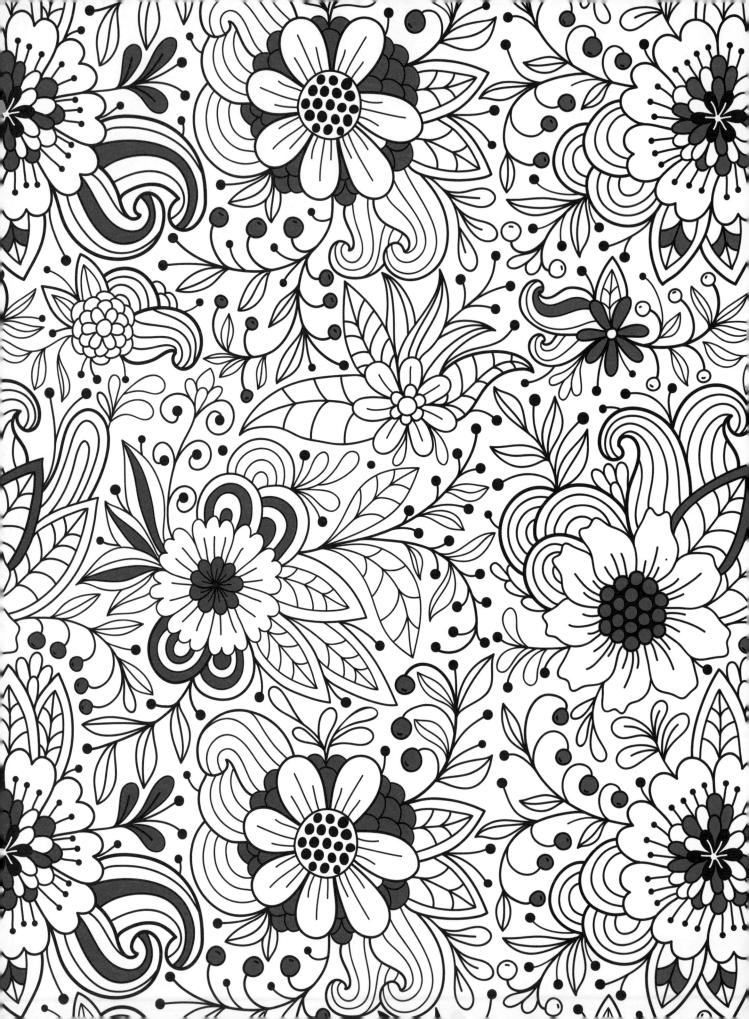

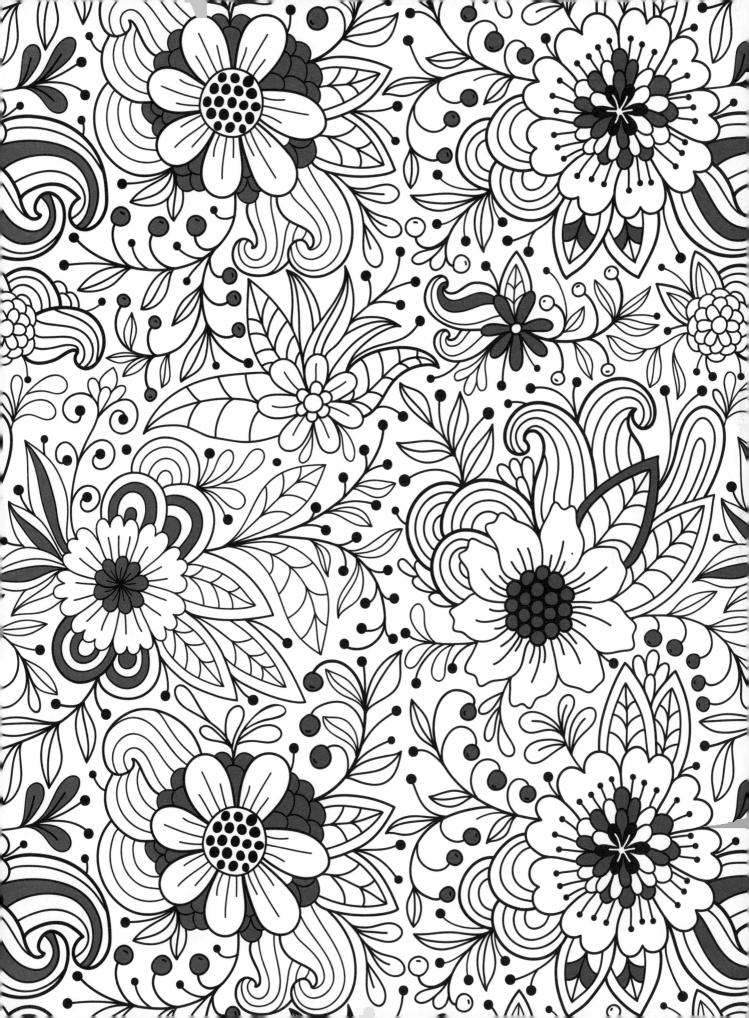

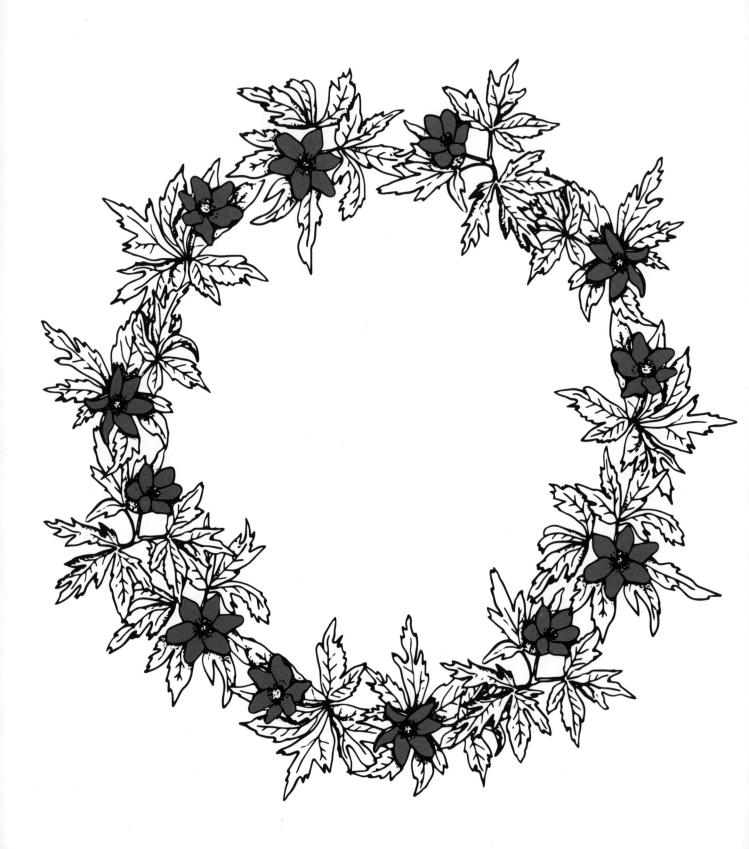

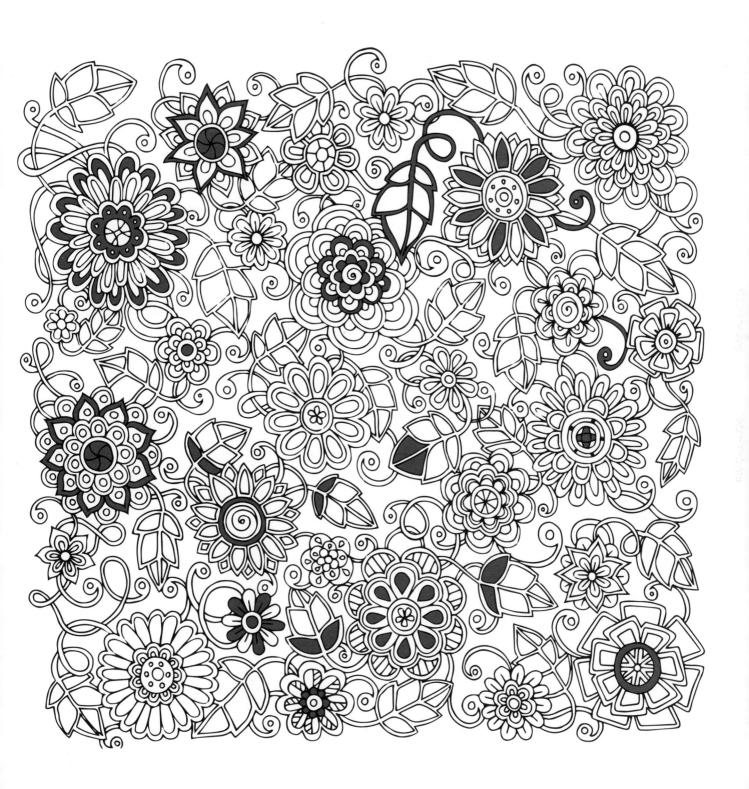

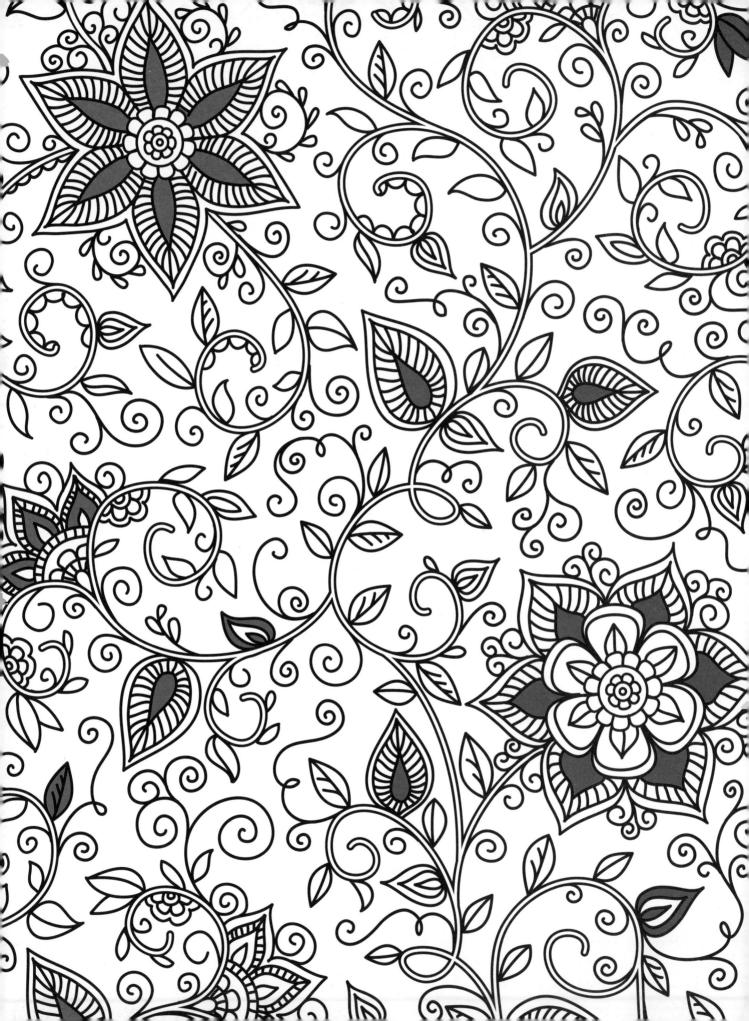

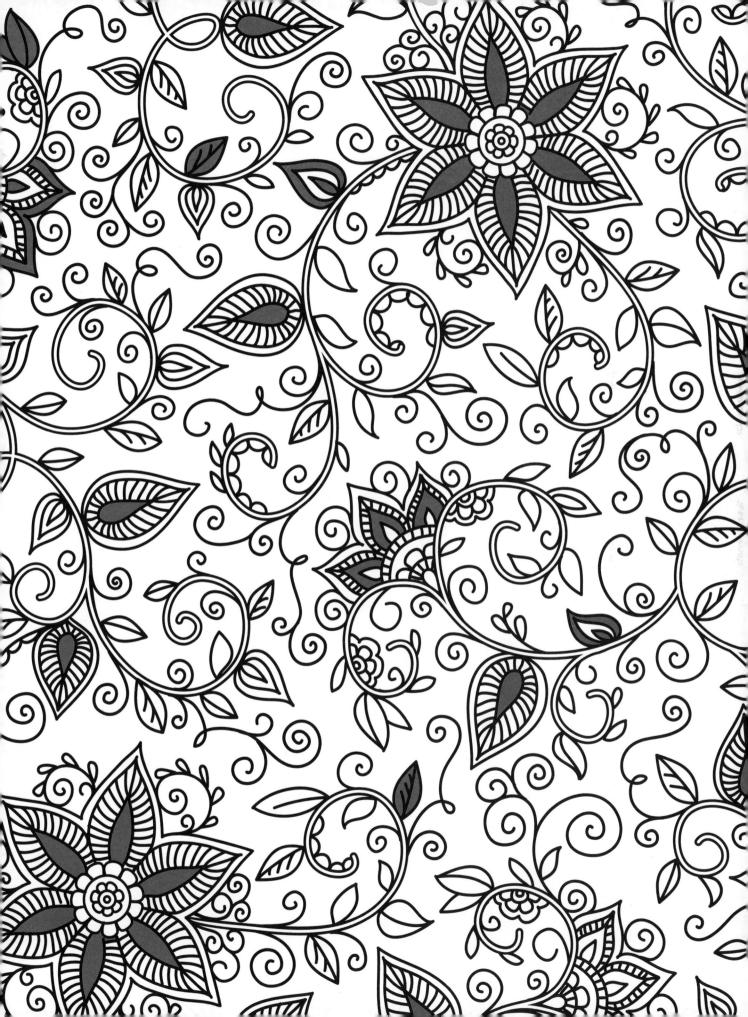

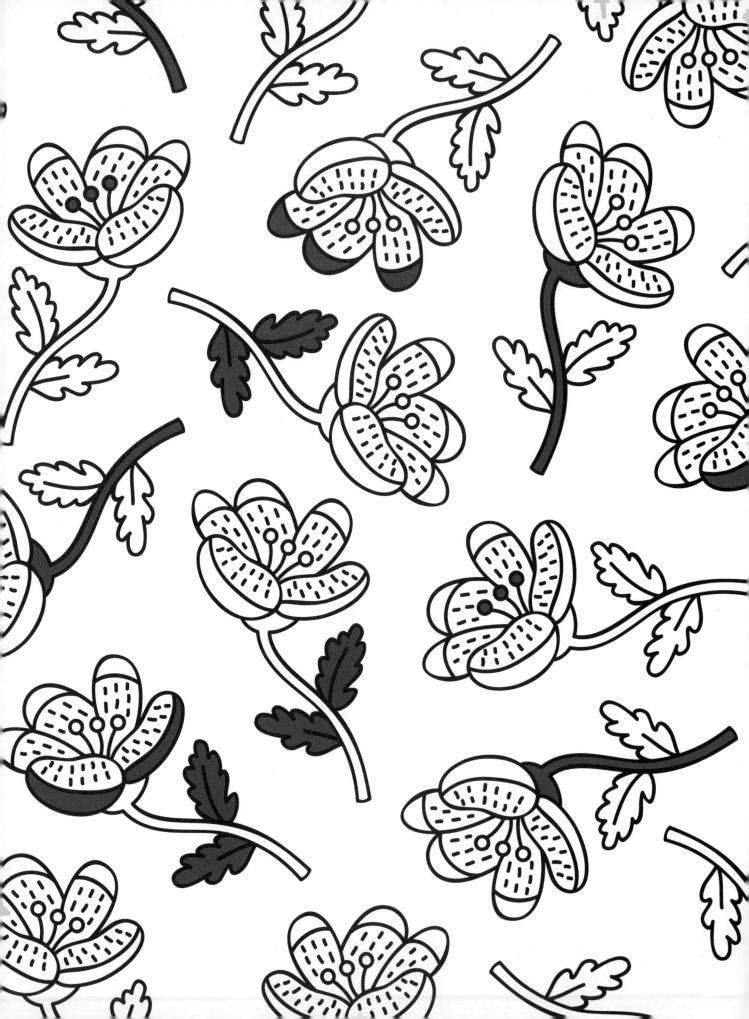

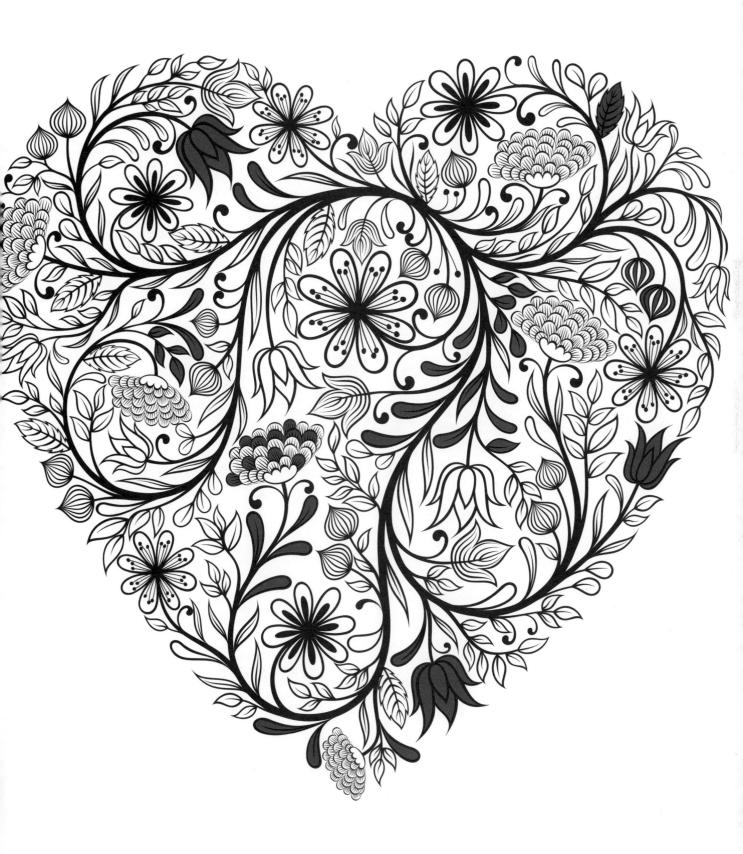

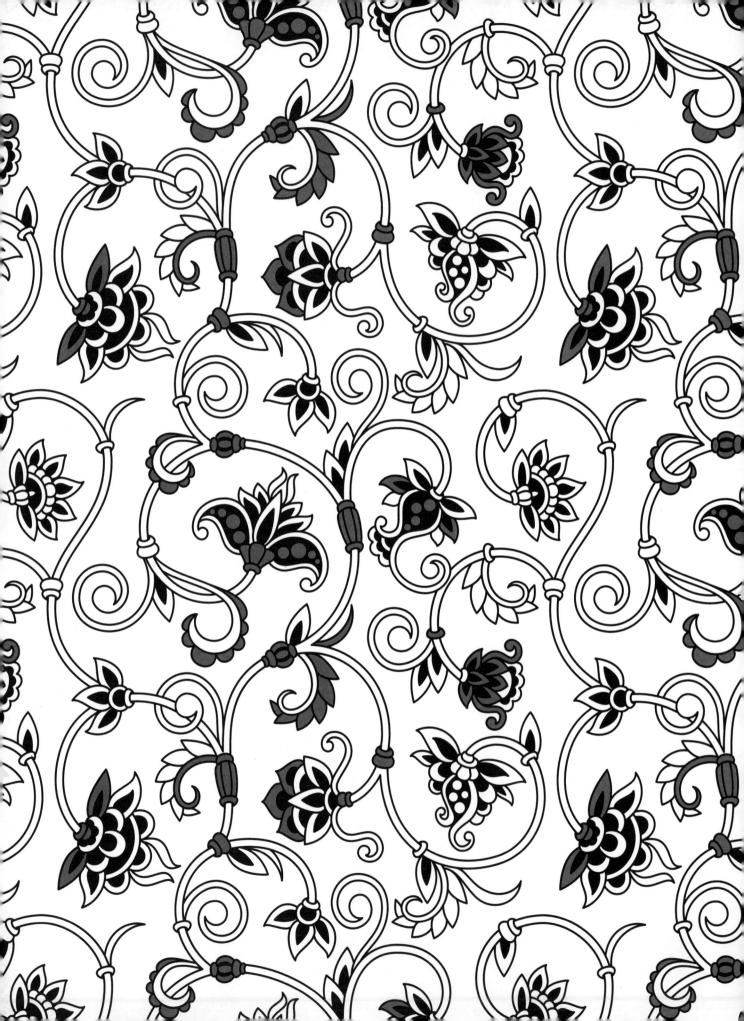

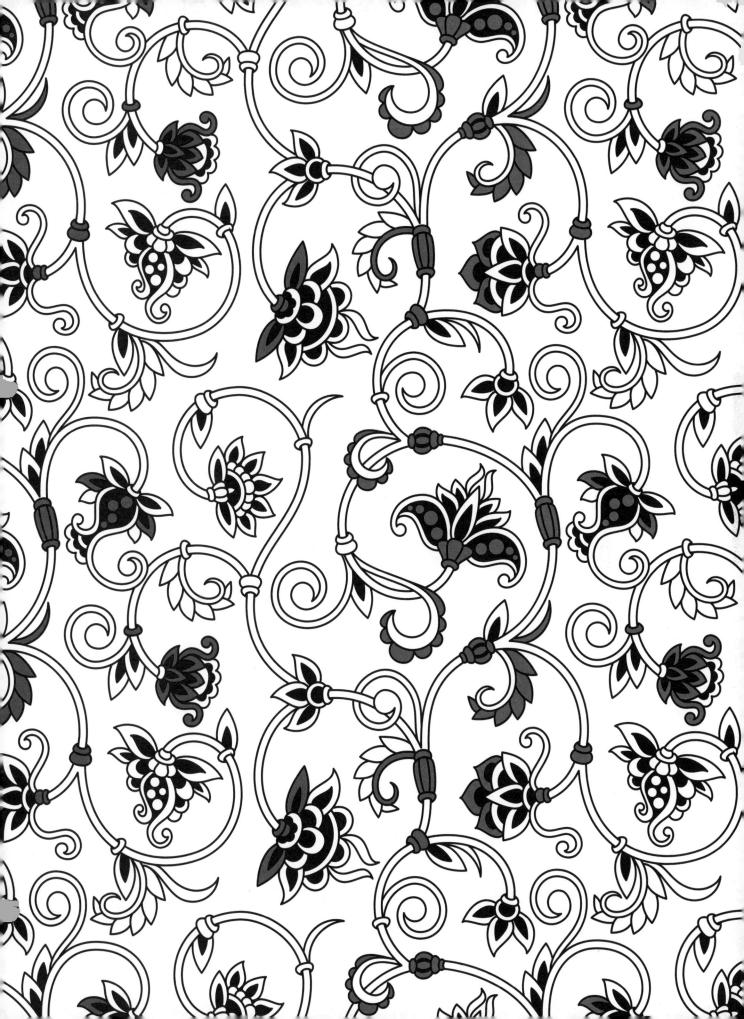

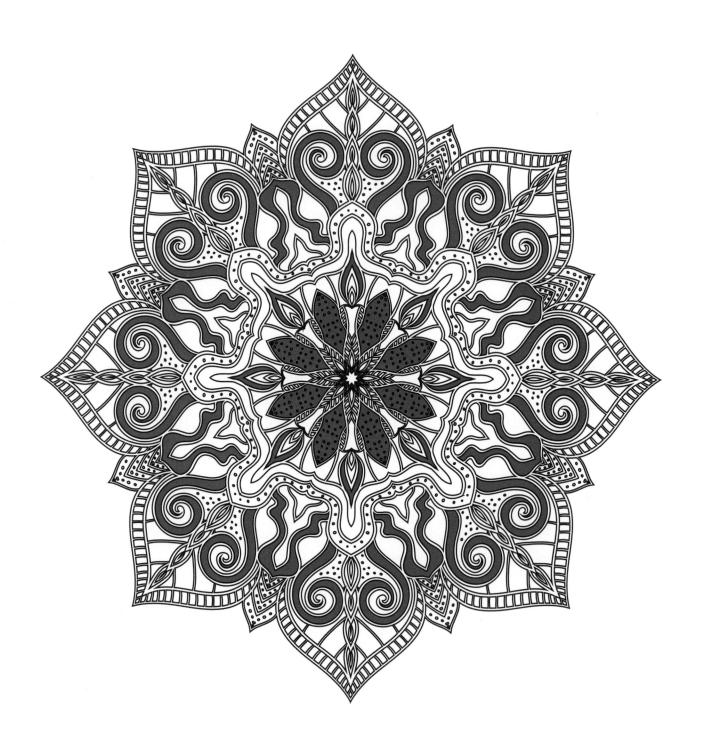

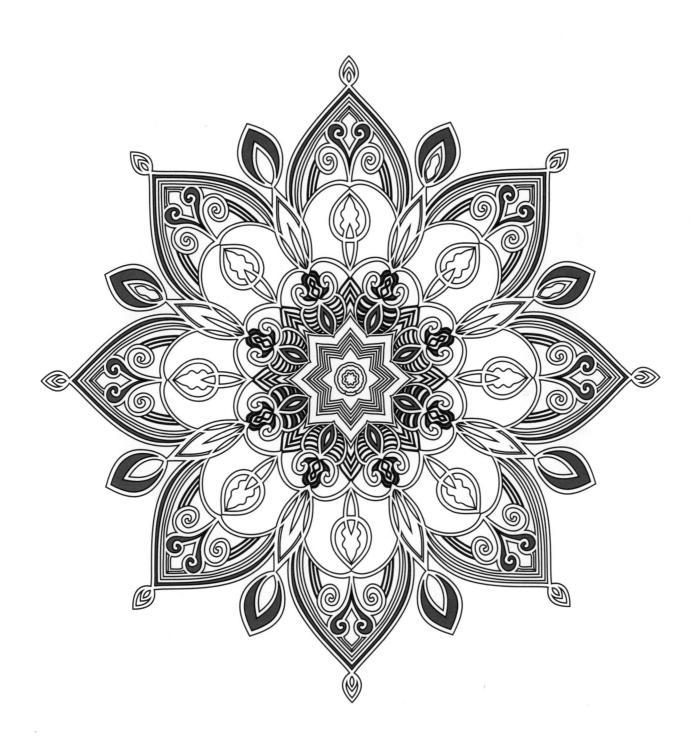

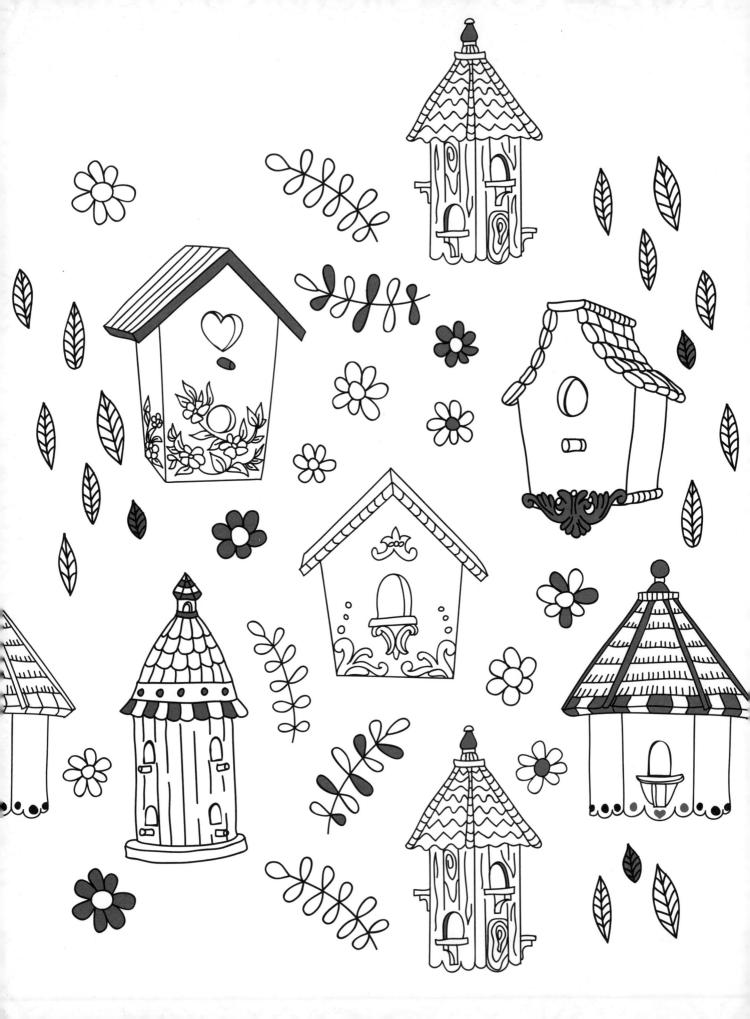

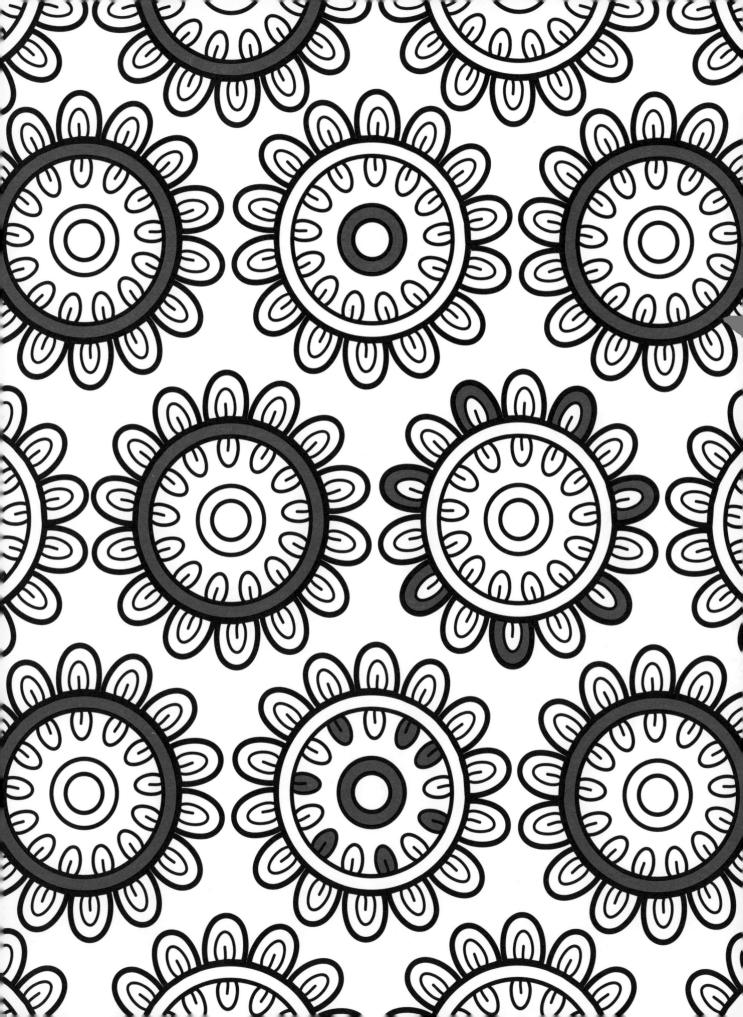

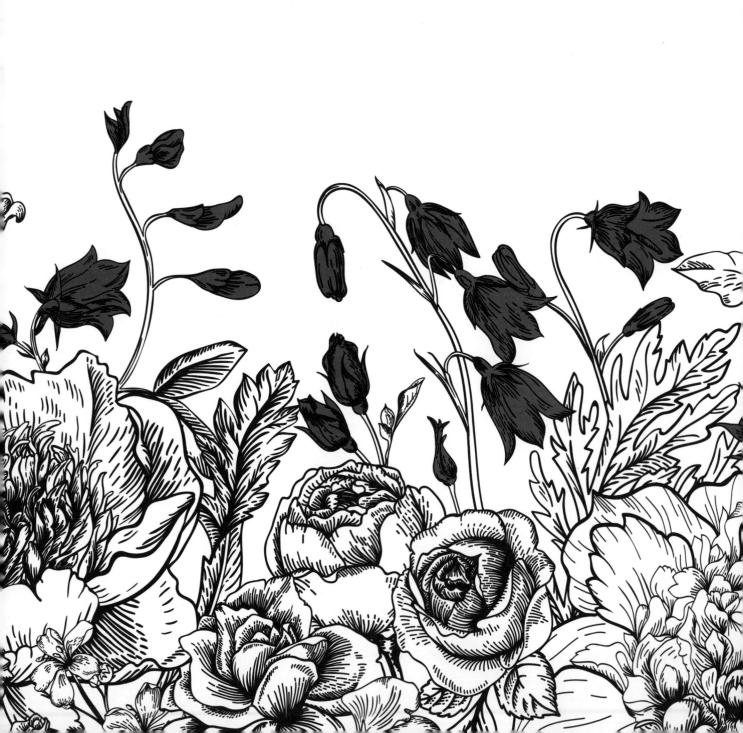

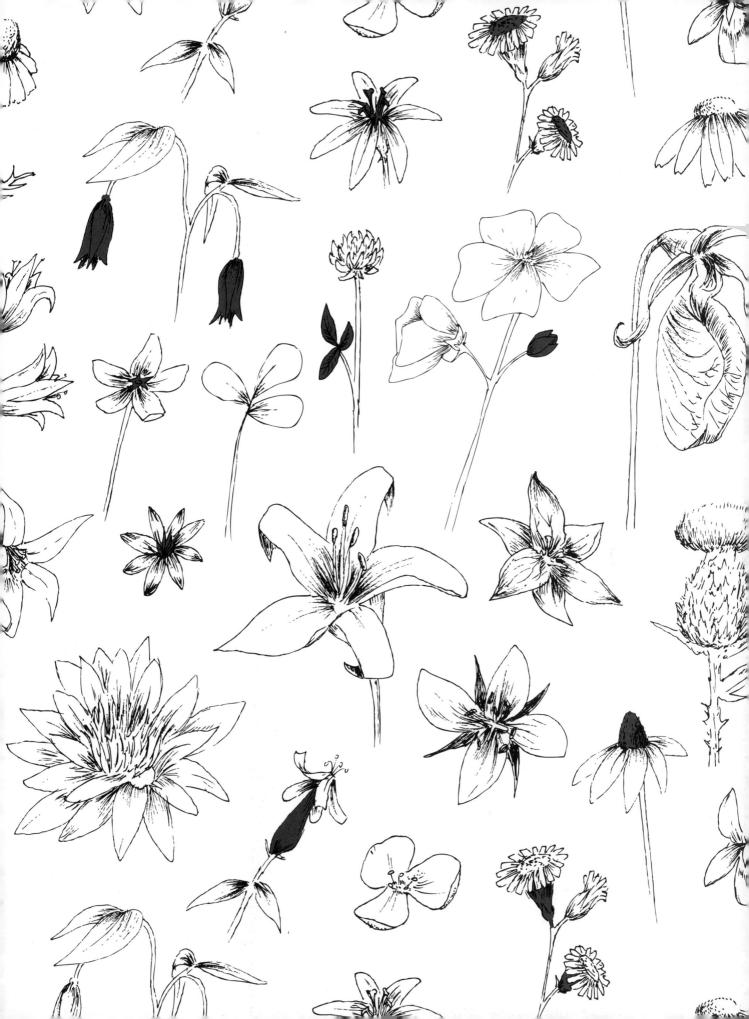

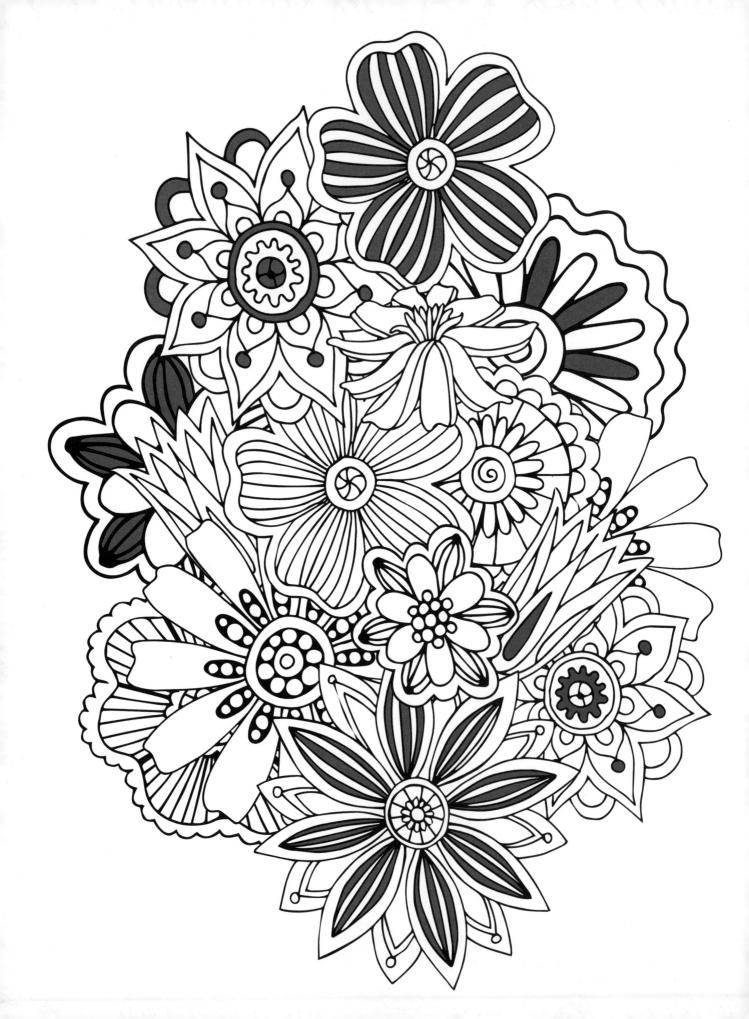

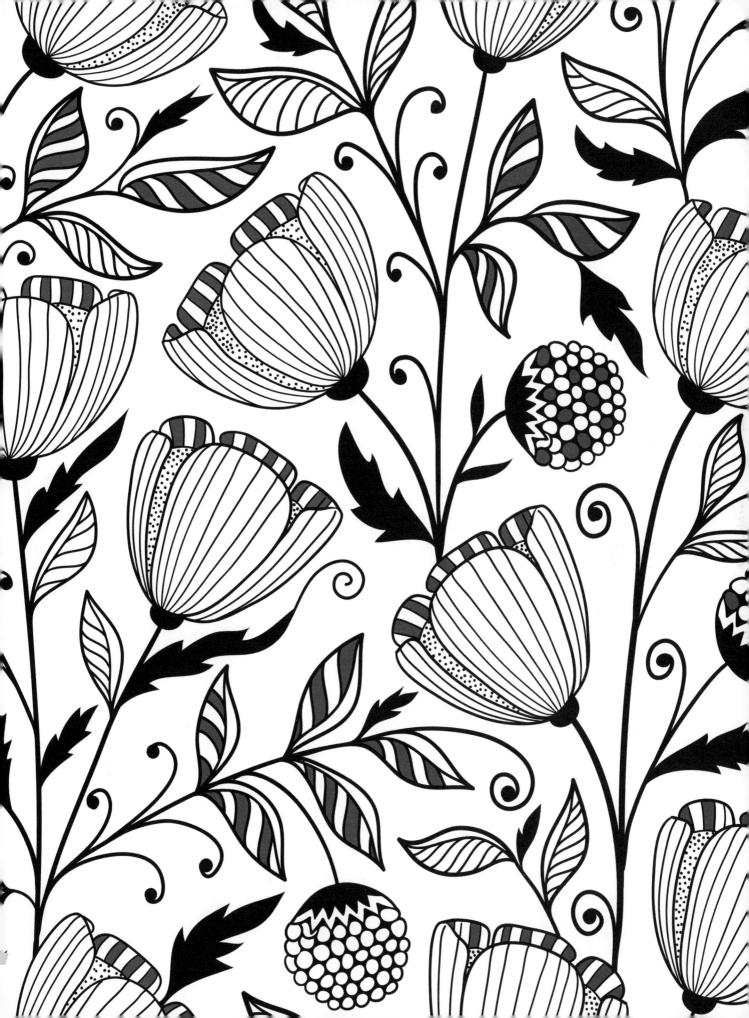

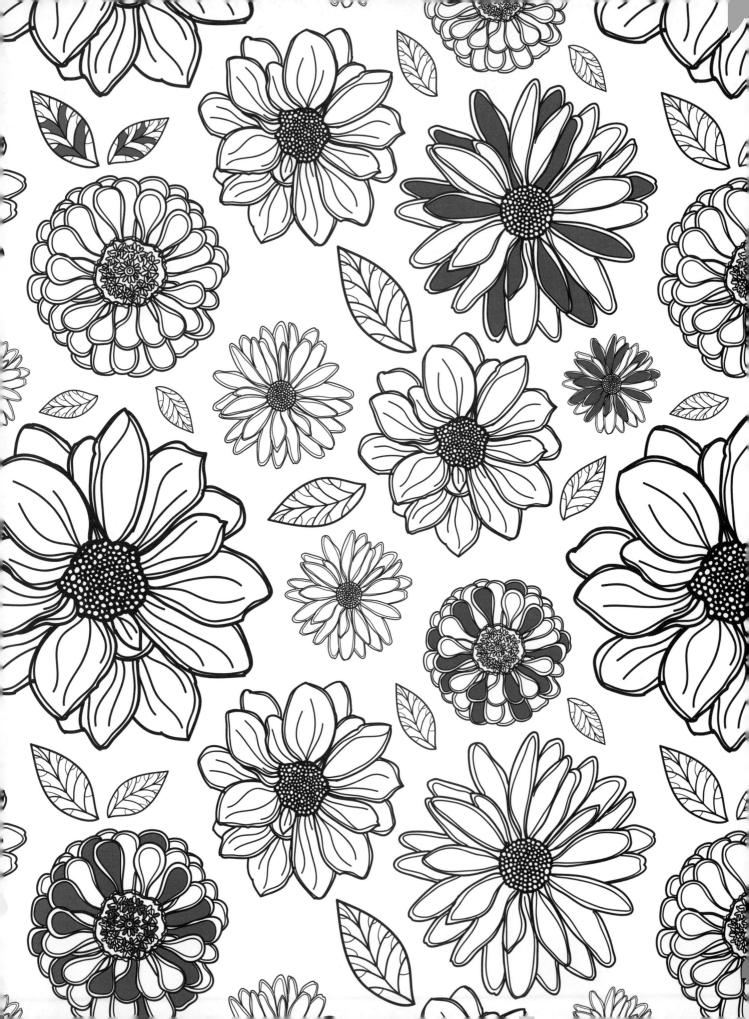

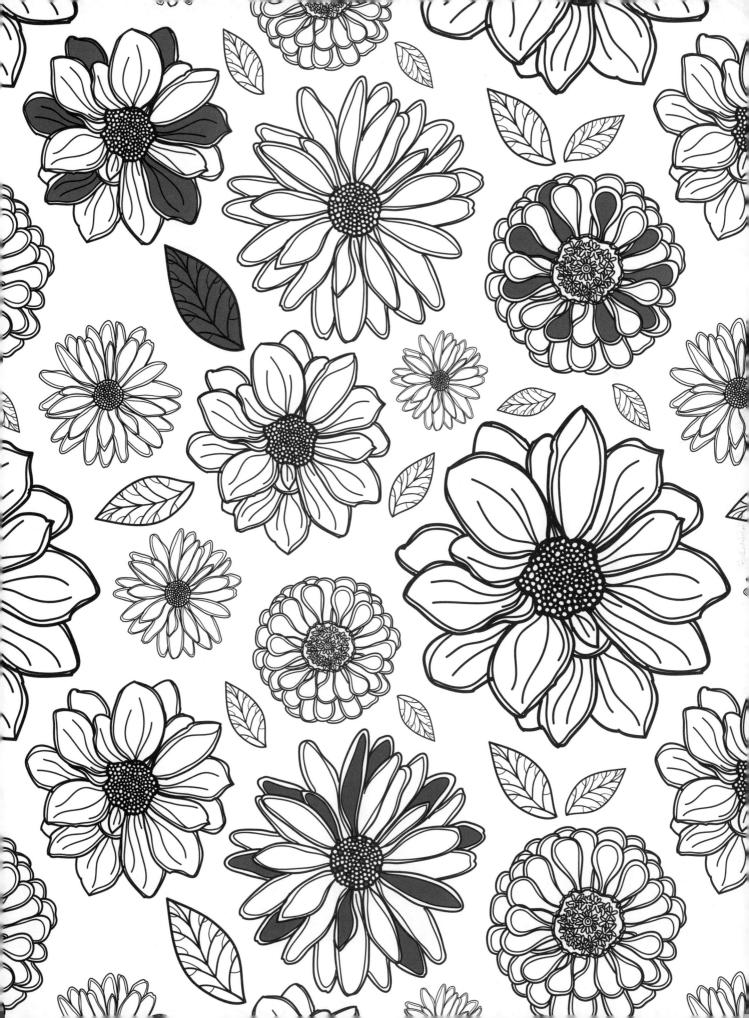

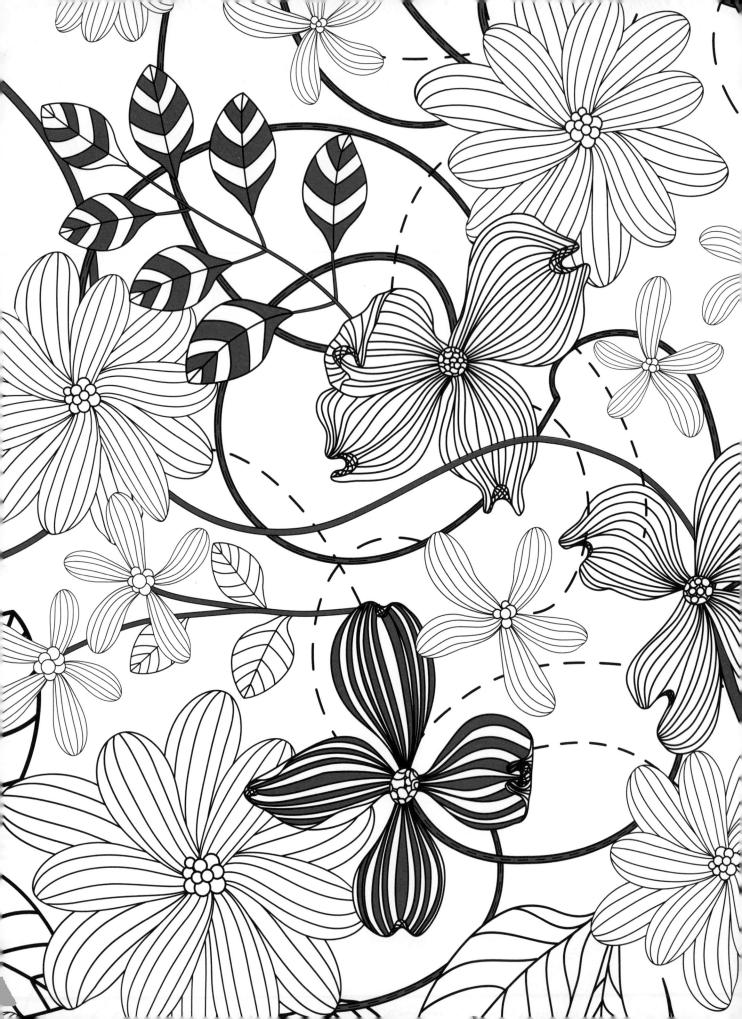

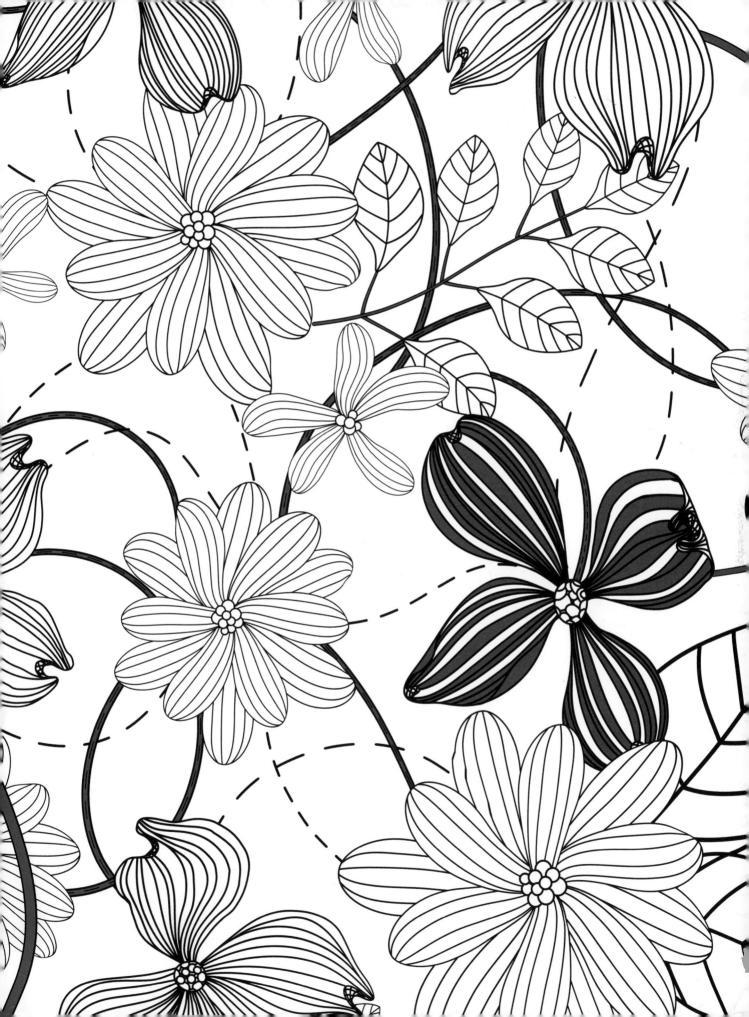

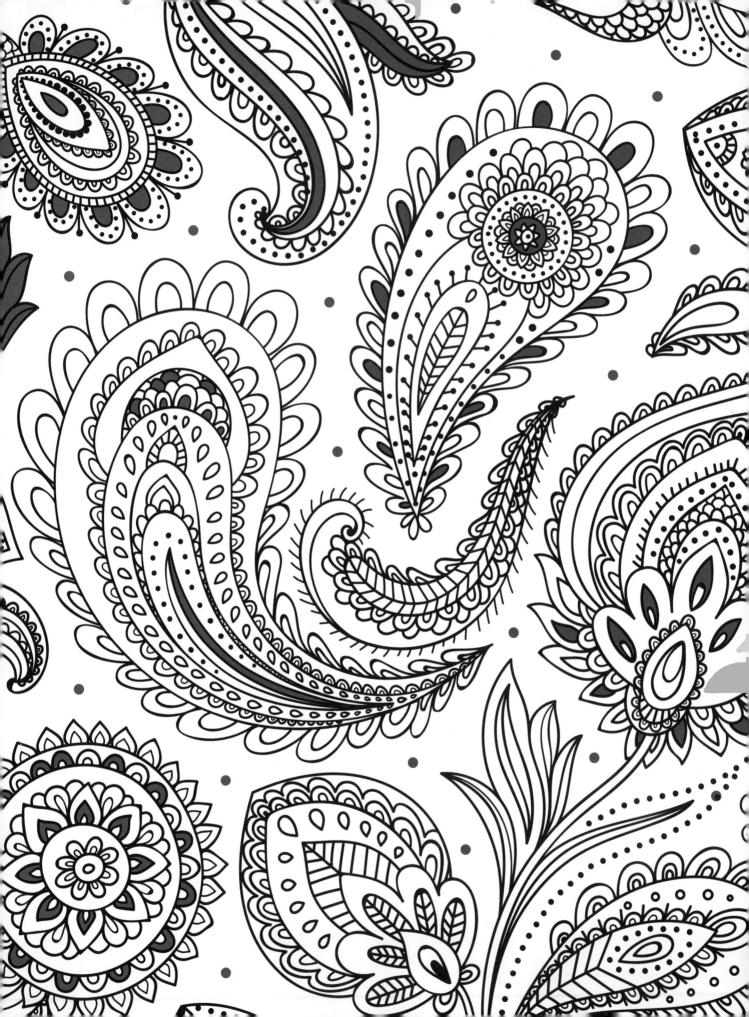

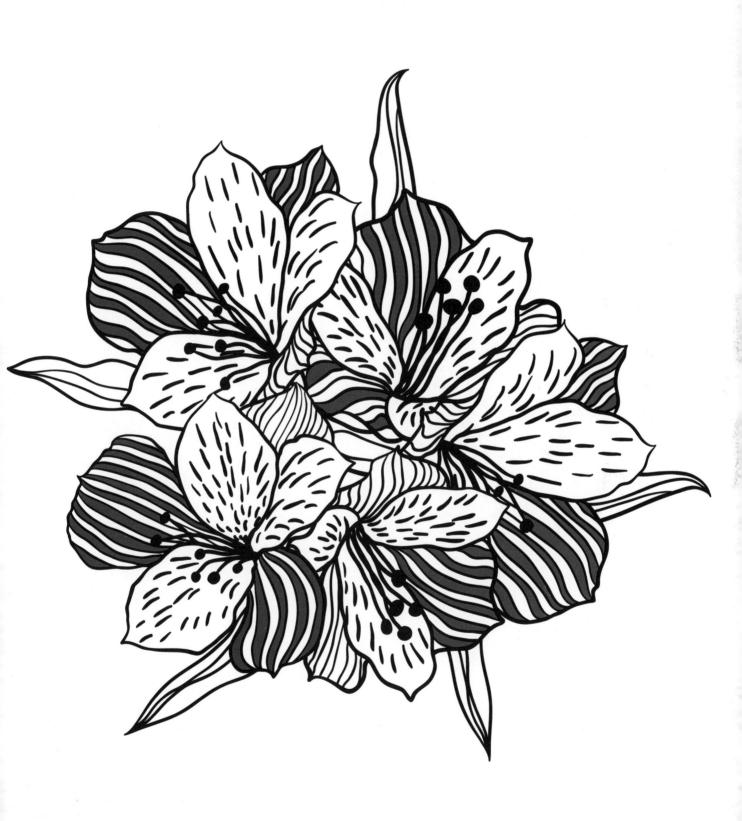

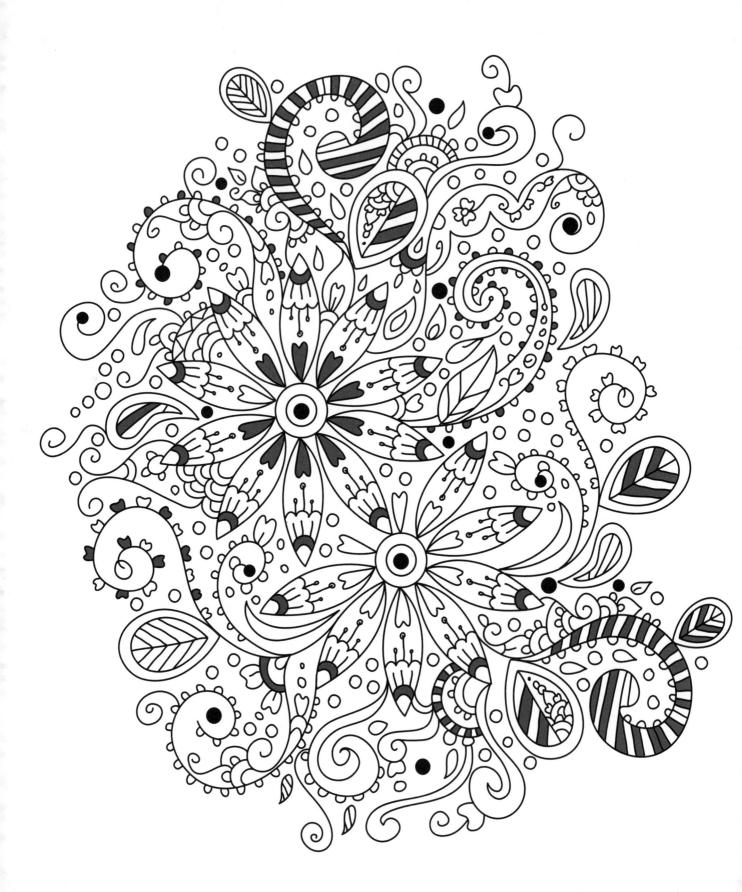

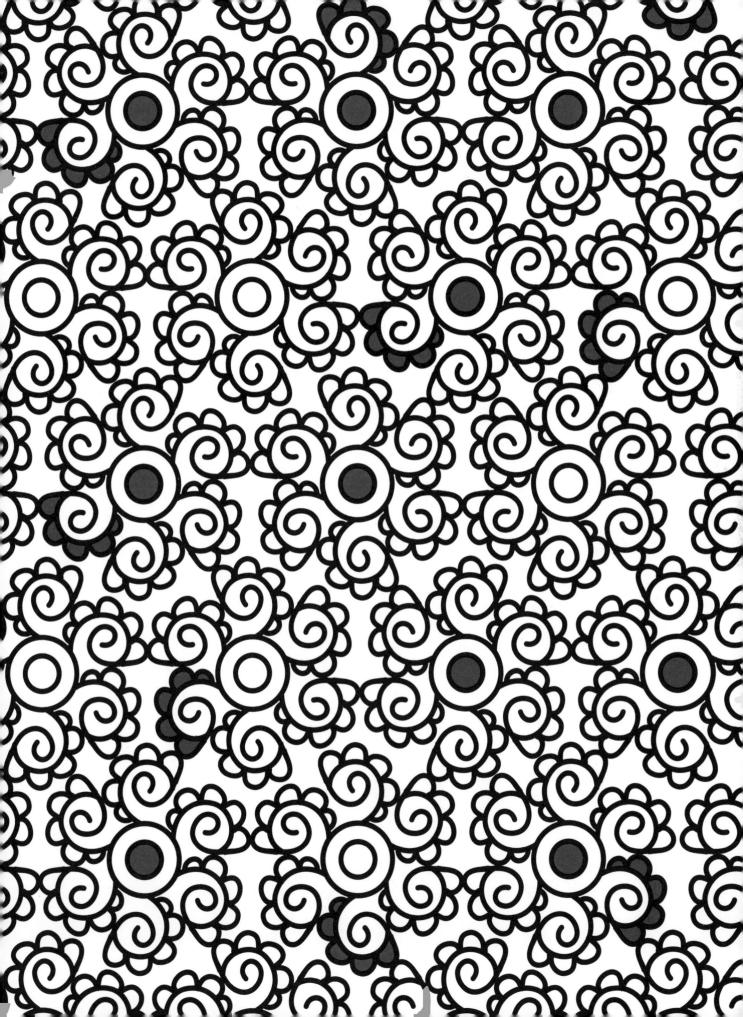